#1 *NEW YORK TIMES* BESTSELLING AUTHOR

SHERRYL WOODS

A Small Town Love Story:

COLONIAL BEACH, VIRGINIA

mira

To that old gang of mine:

Mike Gill, Sue Gill, Mike O'Neill, Marge Owens

and gone far too soon—Patti O'Neill and Bob Owens

Those were, indeed, the days!

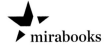
mirabooks

A Small Town Love Story: COLONIAL BEACH, VIRGINIA

ISBN-13: 978-0-7783-6098-8

MIRABooks.com

BookClubbish.com

Printed in U.S.A.

Winchester

Manassas • Alexandria

Harrisonburg

Staunton • Charlottesville

Richmond

Lynchburg

Salem

Roanoke • Petersburg

Radford

Norfolk

Virginia • Virginia Beach

Chesapeake

Bristol

Danville

COLONIAL BEACH

Table of Contents

A Small Town Love Story:
COLONIAL BEACH, VIRGINIA

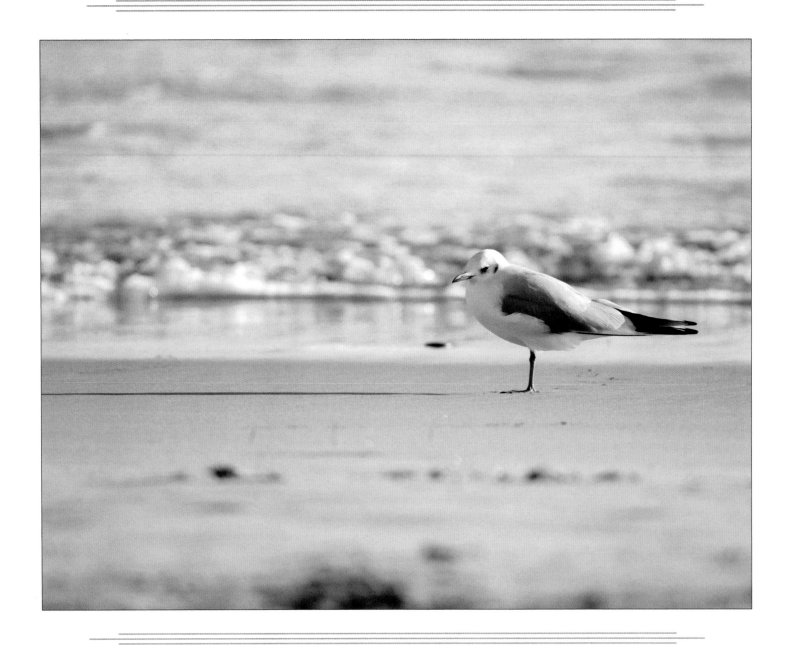

Acknowledgments

I've had a lifetime to get to know the people of Colonial Beach, but never have I had more fun and met more characters than in the months when I was working on this book. I need to thank Kitty Norris, head librarian at the Cooper Branch of the Central Rappahannock Regional Library, who started me on this journey by mentioning that there were so many stories in town that needed to be recorded or written down.

She provided endless assistance and cheerleading to get this job done, as did so many of the people you'll meet in these pages: Ellie Caruthers, Jackie Curtis, Jessie Hall, Alberta Parkinson, Diana Pearson and Mary Virginia Stanford, who were always ready with a bit of town history, a new name for our ever-growing list of possible interviews and a whole lot of laughter. A special thanks to Frank A. Alger Jr., who recorded many of our sessions and created an oral history of Colonial Beach that will provide a lasting resource for those who come after us.

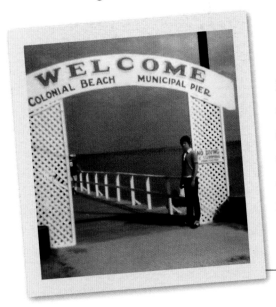

I couldn't possibly have gotten to everybody on our list, including some dear friends who are incredible storytellers in their own right—my favorite electrician, William Hall, and his wife, Joyce, the Reverend Ron Okrasinski, longtime pastor of St. Mary's Episcopal Church (who's so great at eulogies, residents often seek him out to do theirs no matter their denomination), Larry and Andrew Groves, who entertain me with stories on a regular basis, childhood friend Marge Owens and her mom, Mary Burnley Owens. Marge played Drifters

basketball, and Mary Burnley worked for the Texaco distribution company owned by John Ware for many, many years. The list is endless.

Even though there are so many more with stories to tell, I hope this book captures at least the essence of what makes Colonial Beach so unique and special for me and for many of those I spoke to.

Even more, I hope it will resonate with many of you who long for a simpler lifestyle. Most of all, perhaps, I hope it will encourage you to talk to those in your family or in your town who have wonderful stories to share. Get them down before they're lost.

In the meantime, welcome to my world.

Foreword

I grew up in Arlington, Virginia, the very large suburb of Washington, DC, but I was blessed from the age of four by the privilege of spending my summers at a beach cottage in the very small town of Colonial Beach, Virginia. Our house had a wraparound porch, and what I remember most from those early years was riding my tricycle off the edge of the side porch, out of the view of my parents. Or not.

So many stories from those days were exaggerated, embellished or flat-out never happened, but it was summer, and family—parents, grandparents, aunts, uncles, cousins and family friends—was crowded on to benches around a long, banquet-length table in a huge dining room, windows open to the hot breeze, as we cracked piles of Maryland blue crabs. The air was thick with the scent of honeysuckle and the salty bite of the nearby Potomac River. Stories and laughter—along with an antique splatterware coffeepot filled with some sort of "adult" beverage—abounded.

By my teens I had become one of the town's summer kids, though most of my friends were year-round locals. It seemed to me from those lazy, idyllic days that they were incredibly lucky to live in a small town. I wanted desperately to live there, too. I, in my youthful and only-child exuberance for

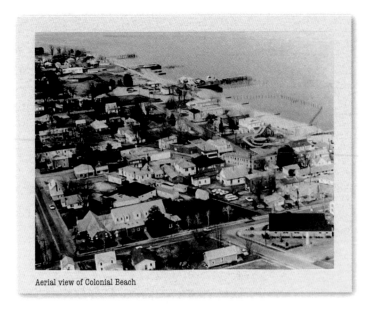

Aerial view of Colonial Beach

what was best for *me*, thought that my mother should be happy to give up her career at a direct mail advertising agency to work as a waitress at one of the town's gambling casinos, and that my dad, who worked for the Alcohol and Tobacco Tax Division of the Internal Revenue Service, could surely find work at the nearby Naval Surface Warfare Center at Dahlgren. Suffice it to say, they were not impressed by my plan.

Undaunted, I continued to beg the adults in my family to accompany me on lengthy summer stays, so

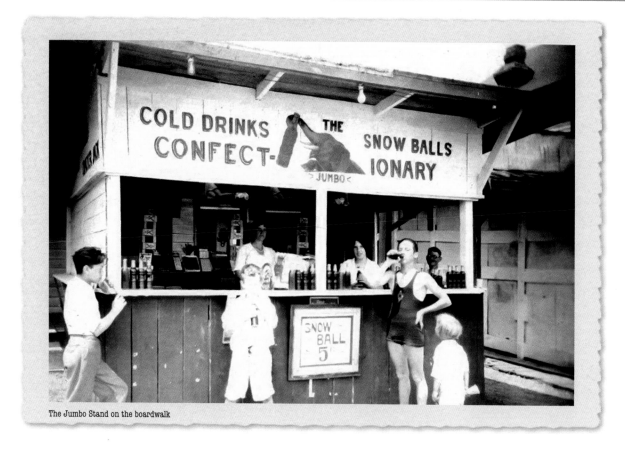

The Jumbo Stand on the boardwalk

I could spend my days on the beach with my friends, snag a lime or cherry snow cone in the evening on the boardwalk, play an endless number of surprisingly energetic card games and bake countless pizzas in an old gas oven we're lucky didn't blow up the house.

Drives around the "Point," where the Potomac River meets Monroe Bay, were an almost daily ritual. In fact, that drive is so ingrained in the lives of many residents that their funeral processions take it one last time.

At Curley's Point with Pete the Bear

Palm Gardens Dance Pavillion and Hotel

Those years and those friends, plus all those lasting memories, created a lifetime love affair for me with small towns everywhere. Every book I've ever written in a small town setting was inspired in one way or another by Colonial Beach, Virginia. A couple of my series, in fact—the *Trinity Harbor* trilogy and more recently, my *Chesapeake Shores* series, which topped bestseller lists as novels and TV ratings charts for Hallmark Channel—were set in this very same region and borrowed from at least some of my experiences over the years.

Colonial Beach has an incredibly unique history, dating back for more than one hundred years in an area that produced the likes of George Washington, James Monroe and Robert E. Lee. Steamboats and ferries brought visitors from Washington, DC, Baltimore and Northern Virginia to stroll a boardwalk crammed with entertainment venues for dancing, dining, bowling and roller-skating.

There was a love-hate relationship with the gambling casinos and the crowds they brought in the 1950s. Watermen thrived with the abundance of crabs,

oysters and rockfish. Local farmers brought truckloads of produce through town, stopping at the homes of their regular customers with everything from tomatoes and string beans to cantaloupes, watermelon and peaches. I loved those tomatoes so much that I used to make my father send them to me via FedEx for my birthday every July when I was living and working full-time in Miami.

Then the casinos were outlawed in 1959. Around the same time, the famous Oyster Wars were fought between the oystermen and the authorities over the dredging of the beds in the Potomac and the Chesapeake Bay. By the '60s, the town had reverted to a quiet, sleepy place that has struggled to find a new identity. While I missed the steamboat and ferry era—I'm not quite that old, after all—I was here for the gambling years, the dramatic ending of the Oyster Wars and every transition that has come since.

Over the years, coming back again and again to the house by the river—rebuilt now into a year-round home, but with a porch and river view and even some neighbors that remain mostly unchanged—I've

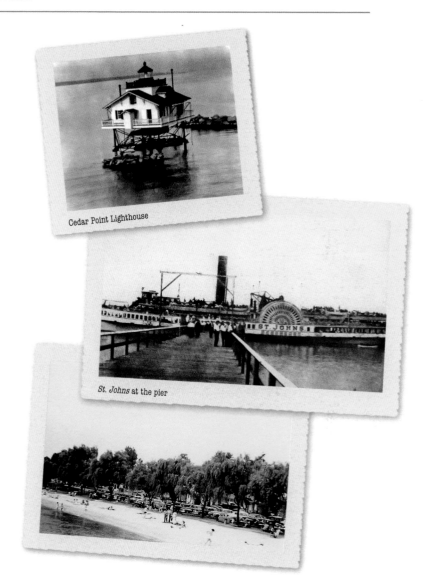

Cedar Point Lighthouse

St. Johns at the pier

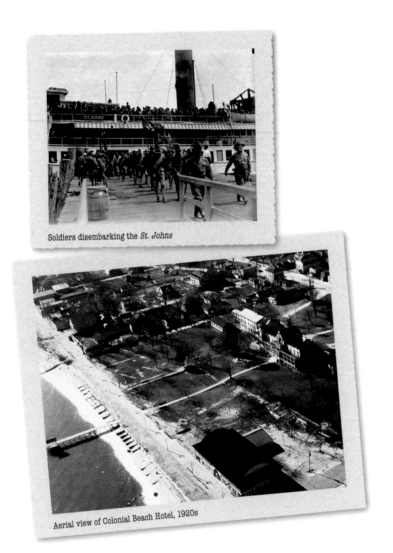

Soldiers disembarking the *St. Johns*

Aerial view of Colonial Beach Hotel, 1920s

discovered that I am far from alone in my love for this place. This town of fewer than five thousand full-time residents is filled with people who were born here and saw no reason to leave, people who left and came home again, and those who came here, fell in love with the place or a person and never left.

Sounds a bit like a romance novel, doesn't it? Just wait till you read about women like Ellie Caruthers, Mary Virginia Stanford and Alberta Parkinson, who met men from Colonial Beach and left their homes and families to build a life here. There are the families—the Curleys, the Densons, the Pearsons and the Wilkersons—who've spent a lifetime right here, their businesses an intrinsic part of the town. Each one is as unique as the characters who have populated my books. They have strong roots in the community and a passion for this town that they're more than willing to share.

This book tells the stories of people I've grown up around and somehow am just getting to know, in that way that we all do with a belated sense of urgency that we need to find out about the histories and the

memories before it's too late for them to be captured. Like Ellie Caruthers, I find myself saying time and again, "That's *so* interesting," as personal stories emerge and real-life love stories take shape.

But more than capturing the history of this town or these individuals, this is a story of small towns and the lure they hold for so many of us who live in large, impersonal cities and yearn for a different lifestyle, one that may be greatly romanticized in many ways, but still exists in so many others. Neighbors do, indeed, seem to know way too much about what we're up to, but they also jump in to help when someone's in need. The schools are the center of much of the social life, right along with the churches and local organizations. The fire department and the rescue squad exist through the heroic efforts of volunteers. I may fictionalize that in my books, but here it's very real.

Just recently I went into a small local grocery and restaurant—you'll read more about Denson's later—to buy a thank-you gift of wine for someone who'd done me a huge favor. They were immediately able to point me toward the brand he prefers. The big warehouse

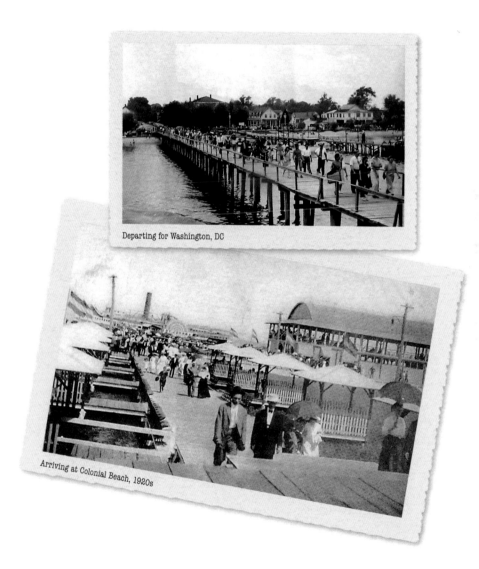

Departing for Washington, DC

Arriving at Colonial Beach, 1920s

wine stores may carry a wider variety of wines, but most can't offer such personalized service. Here, it's commonplace.

Waitstaff know our menu preferences. Neighbors know our habits. For example, following an accident not long ago, I failed to show up for breakfast at my favorite restaurant. The waitress, who'd grown up in Lenny's under the guidance of her stepfather and mom, was concerned. Thanks to Brandy, five minutes after my usual arrival time, another regular customer was knocking on my door to make sure I hadn't been seriously injured, to ask if I needed anything at all. This kind of salt-of-the-earth, genuine caring is something many of us in big cities find lacking in our lives and long for. I hear from readers all the time who can relate to that longing.

So, welcome to Colonial Beach! It's rich with a unique history and charm and a whole slew of great storytellers. In these pages you'll read about their lives, plus a little bit more about mine. None of us are historians and we're not trying to document the past for the history books. Rather, we're sharing pictures and personal stories from many of the phases that this town has experienced, of the people and places that live in our memories and need to be preserved.

I hope you'll enjoy your virtual visit to Colonial Beach with me and that, by the end, you'll understand just a little better why this town has been my inspiration...and the home of my heart.

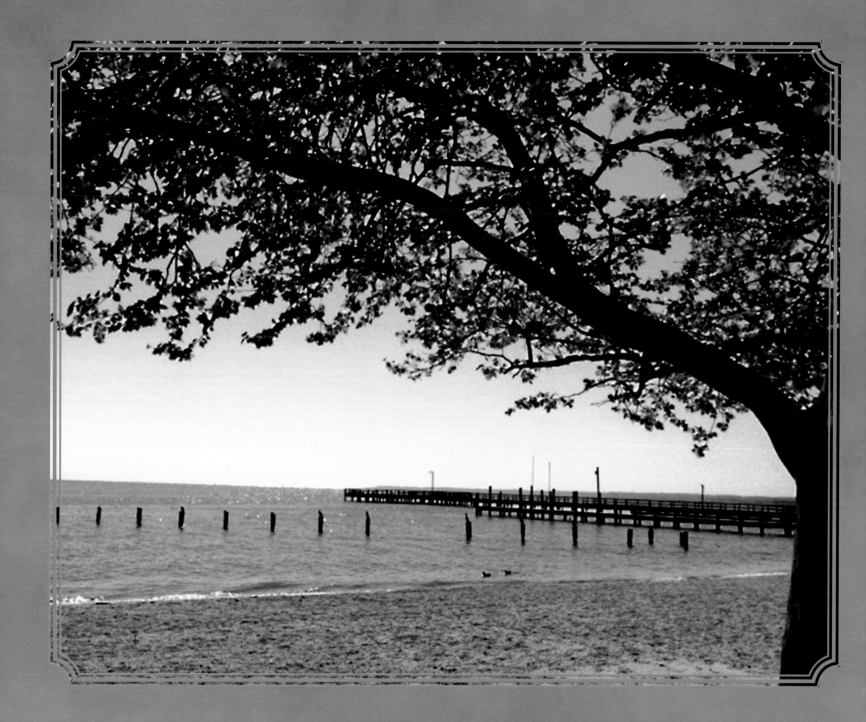

A Look Back:

A COLORFUL PAST, A QUIRKY PRESENT

Colonial Beach, Virginia's amazing draw, can be dated all the way back to Captain John Smith, who allegedly sailed up the Potomac River and wrote of the area's beauty and the plentiful fish in the waters.

In 1650, according to one school report in town library files, the area was first incorporated and called White Beach, because of its wide expanse of white sandy beaches, sand that was sold centuries later to beaches in another state in a shortsighted attempt to put cash into the town's coffers.

One researcher found an early mention of George Washington watching the swans on the Potomac. Whether the swans are descendants or not is hard to say, but there is still a small family of swans in Colonial Beach, and sightings today are always worthy of a quick photo or comment.

Details from those very early times are difficult to come by, but in the comparatively short years since the town was renamed Colonial Beach and filed its town charter in 1892, it has reinvented itself over and over—from a tourist mecca and weekend destination for residents of Washington, DC, Northern Virginia, Richmond and Maryland in the 1890s, to a thriving haven for watermen from tiny, nearby islands seeking better opportunities, from a wild and woolly participant in the Oyster Wars

Bathing beauties on Colonial Beach

of the 1950s, to a nationally known miniature version of Las Vegas with a lively boardwalk and flashy casinos, to its present-day reincarnation as a small quiet, family-oriented summer community. For many years it prided itself on its designation as the Playground of the Potomac.

Some of its stages have been colorful, some peaceful, some worthy of a Hollywood action movie.

Situated on a peninsula of land between the Potomac River at one of its widest points and Monroe Bay, named for President James Monroe, who was born nearby, Colonial Beach is in the heart of Virginia's

Aerial view of the Yacht Center, 2012

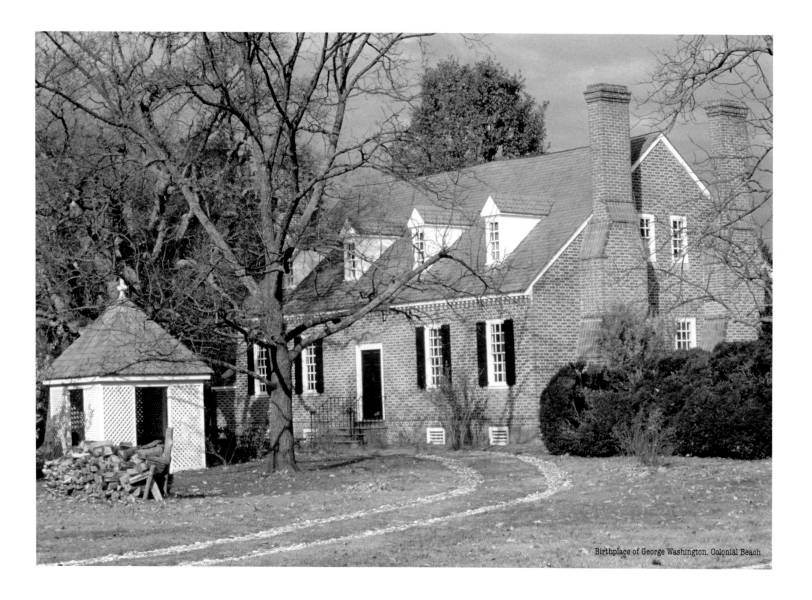

Birthplace of George Washington, Colonial Beach

Northern Neck. It's a region packed with history, including the birthplaces not only of Monroe, but of George Washington and Robert E. Lee. At Yeocomico Episcopal Church not far away, the cemetery provides the final resting places for several original members of the Virginia House of Burgesses from the 1600s.

In its earliest days, when year-round residents were few—well under three thousand by some reports—there were still plenty of reasons for stressed-out folks from far bigger cities to travel to the tiny seaside town. The Colonial Beach Company, among others, operated steamboats from Washington, DC, with a stop in Alexandria, Virginia, to bring travelers to town for the

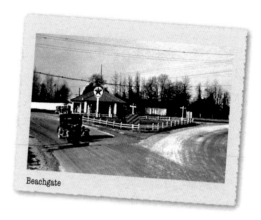

Beachgate

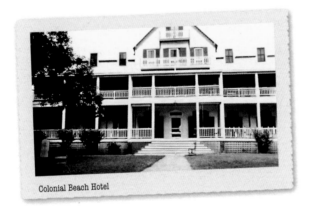

Colonial Beach Hotel

day or overnight to wander the boardwalk, enjoy the entertainment, food and dancing. The *St. Johns* steamboat was the best known of these, so iconic, in fact, that its image became part of the town seal.

In those years, the owners of the Colonial Beach Company were visionaries who saw the possibilities for the future prosperity of the town. In their 1911 brochure, they promoted land sales, home building and keeping lot prices down. "Population creates wealth," the brochure stressed.

To encourage visitors, the *St. Johns* steamboat left Washington daily at 9:00 a.m., except on Mondays and Saturdays. It arrived in Colonial Beach at 1:30 p.m. On

Oldest house in Colonial Beach

Saturdays, it left Washington at 2:30 p.m. to encourage overnight stays. Advertised fares were fifty cents for adults, twenty-five cents for children, with special rates available for church groups.

In those days visitors could stay at one of several hotels in the town, including the sprawling Colonial Beach Hotel, which was once a home owned by General Henry "Light-Horse Harry" Lee, father of Confederate General Robert E. Lee. Several small hotels dotted the boardwalk and nearby side streets. There were rooming houses welcoming visitors as well and, in the evening, the sound of dinner bells ringing could be heard around town calling guests in for the evening meal.

The *James Adams Floating Theater*, reportedly the inspiration for Edna Ferber's novel *Show Boat*, visited Colonial Beach on a regular basis as part of its circuit, and there are rumors that when that boat docked, rats fled onto land even as crowds flocked onboard to see the shows.

When it comes to which business was first established in town and which has been in business the longest in continuous operation, there is confusion. The Bank of Westmoreland, in the heart of what was once downtown, opened its doors in 1904 under the guidance of H.W.B. Williams. It continues in operation today, though under the BB&T name, following a stint as First Virginia Bank. The original building, at the corner of Hawthorn and Irving streets, served for a time as town offices, but now sits vacant and under the threat of being sold and possibly demolished, much to the dismay of historic preservationists and former employees who remember working there in its early years.

One of the earliest aerial images of the town features the main entrance where State Route 205 intersects

with Colonial Avenue. Known as "Beachgate," it once had an actual gate, reportedly to keep cows from wandering away. In that picture there are hints of what life was like in those early years—Blackie Christopher's garage, Mrs. Jenkins's restaurant and Bill Urbanck's blacksmith shop. Today that same intersection features the town's only traffic light, a McDonald's, a BP gas station, the Colonial Beach Police Station, a discount store and a flooring company, among a few other businesses.

Support for the notion that the gate was there to prevent cows from getting loose on the highway comes from the fact that one section of town between Boundary Street and the area locals call the Point was called Cowtown.

Even in those very early years, the full-time residents of Colonial Beach sought out spiritual guidance. The first formal congregation was interdenominational. Founded in the 1880s, Union Church met in various places until it erected its own building, where the Methodist Church sits now, at the corner of Washington Avenue and Boundary Street. Baptists, Catholics,

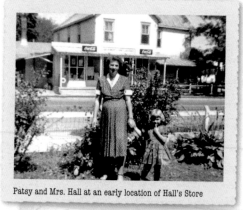

Patsy and Mrs. Hall at an early location of Hall's Store

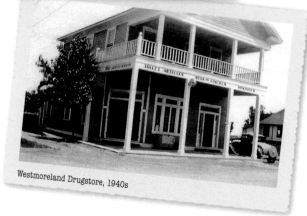

Westmoreland Drugstore, 1940s

Episcopalians and Methodists all worshipped there until each congregation built its own structure. The Baptist church opened in 1896, followed by the Catholic church in 1906. St. Mary's Episcopal Church opened its

doors in 1911. St. Mary's also houses the only pipe organ in town, donated in 1941 by a family that purchased it from a church in Washington that was closing.

One former resident, a Baptist herself, recalls filling in as organist at St. Mary's for her music teacher, Mrs. Van Laer, in the 1950s after Mrs. Van Laer had a heart attack. Grace Roble Dirling was only thirteen at the time and ended up staying on in the "temporary" position until she went away to college. In return Mrs. Van Laer gave her free organ lessons.

During the intervening years between the opening of the Union Church and today, the choices for worship expanded—the Colonial Beach First Baptist Church, which had a segregated African-American congregation, the Colonial Beach Baptist Church, St. Elizabeth's Catholic Church, the Colonial Beach Methodist Church and, among the most recent, the New Life Ministries in 1984 and the River of Life Pentecostal Church.

If the town was lively in its earliest years, thanks to summer visitors who arrived by steamboat or ferry and later, after the opening of the Nice Bridge between Maryland and Virginia via US Route 301, by car, it was nothing compared to the hordes that came during the town's gambling heyday.

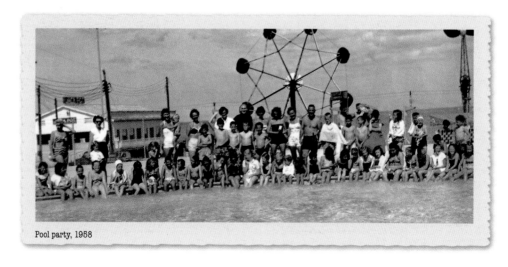

Pool party, 1958

Casinos, built out over the Potomac on pilings past the high water mark to put them officially into Maryland waters, first opened their doors in 1950. Brightly lit with neon signs in true Las Vegas fashion, the Little Steel Pier, Jackpot, Monte Carlo and Little Reno casinos turned the boardwalk into a beehive of activity. Some reports suggest as many as twenty thousand weekend visitors came to town to gamble at the rows of colorful, noisy slot machines.

But if the slot machines were the draw for some adults, there was more than enough for children and families to do along the boardwalk. Amusement park rides sprawled across a grassy area, along with a miniature train—The Little Dipper—that wound its way around the perimeter. Dancing and roller-skating were available in Joyland. Carnival-style games in open booths—a shooting gallery, a ball pitch and ring tosses, among others—drew crowds.

Walk-up food vendors offered everything from snowballs in a rainbow of flavors and frozen custard, to peanuts, popcorn, hot dogs, hamburgers, French fries and corn dogs. Souvenir shops sold the usual

Sunrise over Colonial Beach

mementos. And the sounds of competing bingo parlor announcers filled the salty night air, adding to the allure of their tables of prizes. Some of the carnival and Depression glass items given away for a handful of winning tickets back then are still prized by collectors.

Small hotels with rockers on the porch dotted the boardwalk, as well—Wolcott's, DeAtley's, Fries and Rock's. Alice Rock was something of a town legend and served as grand marshal of the town's Potomac River Festival parade to honor her contributions to the boardwalk's lively heyday.

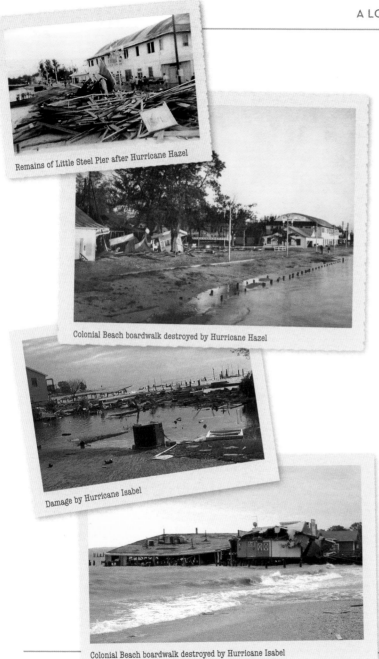

Remains of Little Steel Pier after Hurricane Hazel

Colonial Beach boardwalk destroyed by Hurricane Hazel

Damage by Hurricane Isabel

Colonial Beach boardwalk destroyed by Hurricane Isabel

When it came to merchants in town, among the most notable were the Foxes, the Coopers and the Klotzes. One of the first general merchandise stores was opened by Harris Fox on Hawthorn Street and touted that it sold everything from "candy to caskets." The Klotz family later opened its Gem Five and Ten Cents store in that location. Not far away, Cooper's was opened with an equally diverse range of merchandise. Its slogan was "We Sell Everything." After it closed, the land was donated to the town and became the Cooper Branch of the Central Rappahannock Regional Library and the Colonial Beach Town Center.

Though far inland from the Atlantic Ocean, Colonial Beach has not been immune to hurricanes and other major storms. A 1918 storm destroyed property and wharves in town. Further damage was done by another storm in 1933. Hurricane Hazel in 1954 slammed into the boardwalk and knocked casinos from their pilings. There were reports of residents flocking to the Potomac in search of any surviving liquor bottles and coins from the slot machines. Hurricane Agnes hit in 1972 and most recently, in 2003, Hurricane Isabel

destroyed or seriously flooded restaurants and other property on the water.

During virtually the same years as the gambling heyday, there was a different kind of chaos on the waters of the Potomac. After World War II, both Maryland and Virginia banned the dredging of oysters from the bottom of the river. Dredging, experts believed, destroyed the oyster beds. Oystermen were restricted to tonging, a more labor-intensive technique intended to protect the beds and keep oyster supplies flourishing.

Maryland patrol boats, however, were reportedly far more aggressive about enforcing the restrictive law than Virginia officers. And Virginia-based watermen were seemingly far more determined to harvest oysters by dredging. They took their boats, often equipped with exceptionally fast surplus military engines, out at night and continued dredging. These cat-and-mouse games during the era that came to be known as the Oyster Wars erupted into wild chases on the water with guns blazing and spectators on shore observing the battles as if watching a Hollywood action movie.

Only when the battle turned deadly in 1959 with the shooting of Colonial Beach waterman Berkeley Muse did the Oyster Wars end. Legislation eventually formed the Potomac River Fisheries Commission in 1962 to regulate fishing, oystering and crabbing on the Potomac. In the documentary, *Watermen of Colonial Beach*, written and directed by John Sweton, the then-head of the Fisheries Commission, Kirby A. Carpenter, was asked if the commission had been successful. His reply: "I don't know if it's been successful, but nobody's lost their life over a damn oyster."

With access to the casinos in town outlawed in 1959, around the same time as the end of the Oyster Wars, life turned calm in Colonial Beach. Crowds no longer flocked to the tiny seaside town. Hotels and motels closed. Buildings along the boardwalk stood vacant and were eventually sold to the town and torn down. The landmark Colonial Beach Hotel took in its last customers in 1981 and was torn down in 1984.

Some say that was the beginning of the end for the tiny community, still with fewer than five thousand

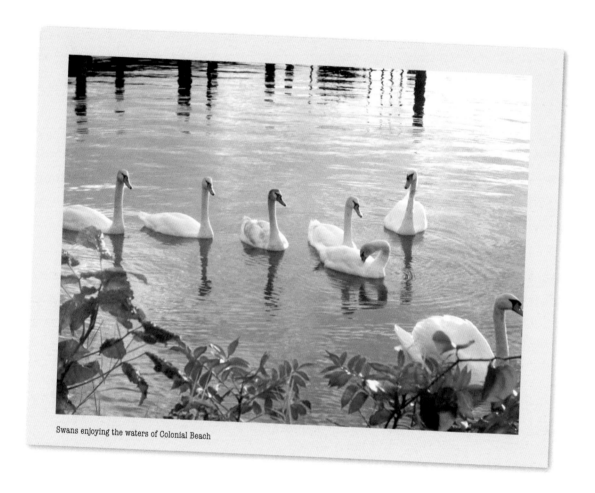

Swans enjoying the waters of Colonial Beach

year-round residents. Others point to another change that affected the town's identity. Its first actual shopping center, on Euclid Avenue at First Street, opened in the 1970s with an A&P grocery store, a drugstore, a Ben Franklin and a hardware store. The post office, which had also been at the center of the once-thriving downtown area where people crowded the sidewalks on Saturdays especially to shop, chat with neighbors and get their mail, also moved to First Street, about a block from the shopping center. That change ended the days of an informal gathering place where news was shared.

Now neighbors run into each other on a casual basis only during the Second Friday Art Walks to various galleries scattered around town, at one of the summertime concerts or events on the town's green, at church suppers or occasionally in the aisles of the Food Lion or Hall's store just outside of town.

Like all small towns, times in Colonial Beach have changed. It has reinvented itself time and again over the years and, no doubt, will again.

Sloan Wilson, famed for writing *The Man in the Gray Flannel Suit*, which later became a movie starring Gregory Peck, lived for a time aboard his boat at Stanford's Railway Marina on Monroe Bay. In his self-published book, *A Talking Boat: The Story of the Yacht Hermione*, he described Colonial Beach as a town that "has a lot of quirky charm" and "a somewhat raffish reputation."

Locals prize those apt descriptions, but wonder if they'll ever apply in quite the same way again.

REMEMBER WHEN:
Jackie Shinn

Perhaps no one in Colonial Beach has more of a fondness for and knowledge of Colonial Beach history than Jackie Shinn. Not only has she lived in town her entire life, having grown up in her grandmother's boardinghouse, but for many years she and her dear friend Joyce Coates operated the Another Time antiques shop and wrote columns for the weekly *Westmoreland News* called "Remember When."

"Our most popular column ever was about the Eastlake murder," she says without hesitation.

It was a grisly story that few newcomers to town knew anything about, but it was the stuff of local gossip for years after it happened.

Miss Sarah Knox, a nurse from Baltimore, was charged with the September 30, 1921 murder of Mrs. Margaret Eastlake, the wife of Miss Knox's alleged lover, Roger Eastlake. Eastlake, a naval petty officer stationed at the Naval Surface Warfare Center, Dahlgren Division, was also charged in his wife's death, but later acquitted.

Articles from the time describe the murder weapon as a newly sharpened hatchet and the scene as a particularly bloody one.

Not long before the tragedy, Mrs. Eastlake told a friend that she feared for her life. The witness testified that she and others with whom Margaret Eastlake had shared her fears had dismissed them. She hadn't been calmed by their reassurances and told her friend, Mrs. Rachel Collins, that she planned to leave her husband, take their two children and return home to Philadelphia. That decision came too late.

The tragic scandal rocked the town, according to Jackie.

Most of the stories and bits of history that Jackie and Joyce shared with readers were far more benign. Their columns were filled with information and nostalgic photographs. "People were glad to share the information and pictures they had," she says of their efforts that lasted until new owners took over the paper and the column was discontinued.

Many of the columns were collected and self-published in volumes that are available at the Colonial Beach Historical Society and at the town library. They also put together another book, a pictorial history crammed with photographs they had collected.

Their efforts to preserve bits of town history to inform residents about the town's fascinating past also had a very practical application. When a building at the corner of Washington Avenue and

Jackie's grandparents

Society, and were given honorary memberships in that organization.

Jackie's own family story figures in the town's historic past, a time when many visitors to the small resort community stayed in favorite rooming houses. While there were any number of homes taking in guests in that era, her grandmother's rooming house drew large crowds for meals.

"It was nothing for her to serve a hundred people for dinner," Jackie recalls. Many of them were guests in other homes, but took their meals with Jackie's grandmother.

"We'd have chicken on Sundays with mashed potatoes, peas, lima beans. It was served family style," she says. "There was always homemade cake and ice cream, too."

She adds, "I can cook, but not like they did then." Her mother would even pack lunches for guests who planned to spend the day on the beach or boating.

"We'd sit on the porch and sing at night," Jackie remembers with unmistakable nostalgia. "One man had a beautiful voice and played the piano. Another played a guitar."

Jackie's grandmother

Hawthorn Street was about to be demolished, they provided information on its past as host to a wide variety of businesses, including an early telephone company location where residents without phones could make calls. They were credited with saving the building, which now houses the Colonial Beach Historical

Her grandmother was careful to assign any potential troublemakers to a second house, rather than the one where she, her sister, Connie, and their mother lived. Those guests went to a different rooming house.

Jackie and her husband, Donnie, who originally moved to town from North Carolina, lived in one of those former rooming houses until recently. "It was way over a hundred years old," Jackie says with real regret. "Things were beginning to happen to the house. The earthquake a few years ago [in 2011] didn't help. There was just too much that had to be fixed." They sold it for the price of the land.

Jackie's husband, Donnie

While Jackie's own ties to Colonial Beach ran deep, Donnie's weren't as strong. He was already sixteen when he and his family came to town. He worked at Reno casino for a time. He drove the school bus.

Eventually he spent five years in the army and developed an interest in computers. He got two degrees and worked for a contractor at Dahlgren. His work was related to the nation's Tomahawk missile program. He taught at Germanna Community College and at Dahlgren as well, even after he retired.

During that time, Jackie ran the tiny Colonial Beach office for the county's weekly paper, the *Westmoreland News*. For forty-five years she sold ads and wrote the community news. For thirteen of those years she co-wrote the "Remember When" columns.

She laments the fact that so many old buildings are being torn down, but feels she and Joyce did their part to record the fascinating bits of history that are slowly being lost as buildings come down in the name of progress or just because no one had the foresight to preserve them well.

"We had so much history here. Everybody loved Colonial Beach then. It reminds me of Cabot Cove,"

she says, referring to the fictional town on TV's *Murder, She Wrote*. "We didn't have to worry about things."

Back in the day people gathered on the boardwalk just to watch all the activity, have a snowball and catch up with their friends.

"There's nothing there now," she says. In fact, one of the last things to draw a crowd on the boardwalk was the stacking of the modular units that became a condo building just a block away from the town pier. Locals brought chairs and sat for hours to watch them being lifted into place.

For Jackie that brief bit of excitement was nothing compared to the way it used to be when the boardwalk was crowded with activities, including a variety of bingo parlors. "I won a starburst clock at one of them," she recalls. "It stayed on my living room wall for years."

Many people in town still have bits of carnival glass, Depression glass or other prizes from those days.

Her love for the town is evident in everything she says, in the descriptions of her fondest memories. "Donnie thought about leaving," she admits. "But he knew I loved it here."

And so they stayed, surrounded by memories that not only filled her heart, but gave her in many ways her life's purpose.

Another Time Antiques Store

Jackie Shinn today

EDITOR'S NOTE: *Donald Shinn passed away on January 13, 2017, but Jackie continues to live in her beloved Colonial Beach.*

A NAVAL NEIGHBOR

Though the Naval Surface Warfare Center Dahlgren Division is not in Colonial Beach or even in Westmoreland County, it is one of the town's largest employers of both navy and civilian personnel in jobs ranging from computer specialists and engineers to painters and secretaries. In all, its staff of approximately 5,200 from Colonial Beach, King George County and beyond is actually larger than the entire population of Colonial Beach. Many of the people you'll meet in these pages have worked on the base in one capacity or another.

Opened in 1918 and named in honor of Rear Admiral John Adolphus Dahlgren, a Civil War-era navy commander with a specialty in ordnance, Dahlgren's Potomac River Test Range has allowed for the test firing of various weapons developed by base experts. Patrol boats are still visible on the river on days when tests are being conducted to keep boaters out of the range.

The booming sound of those tests shakes the ground, sends dogs into a frenzy and leaves pictures on the walls of every home perpetually crooked.

Amazingly, during my college years, I often played golf on the base course with a friend who was on his college golf team. Whenever I hear a professional golfer grumbling about the click of a camera shutter, I think perhaps he or she should spend a few practice sessions at Dahlgren with those guns firing. Nothing as inconsequential as a camera shutter would ever affect his or her concentration—or backswing—again.

I also recall a particularly noisy day right after the start of the first Gulf War when a couple of missiles fired from warships reportedly missed their mark. The testing of those guidance systems went into overdrive on the Potomac, and corrections were seemingly made within hours of the misfires, a real-time demonstration of the value of the work being conducted on the base.

Walter Purcell and buddies, WWII

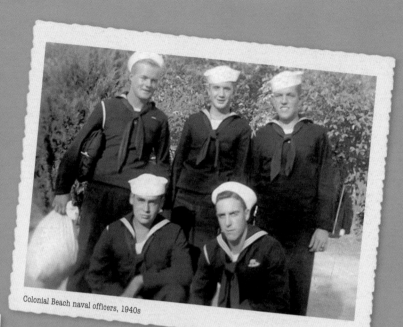
Colonial Beach naval officers, 1940s

The War Memorial in Colonial Beach

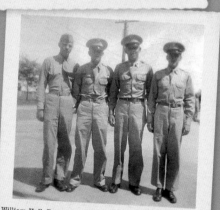
William Hall, Tommy Powell, John Lewis, Donald Hall, 1948

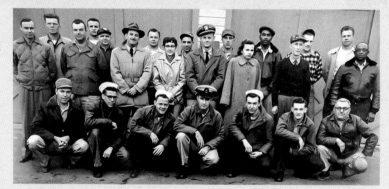
Naval Proving Ground, Dahlgren Virginia, 1955

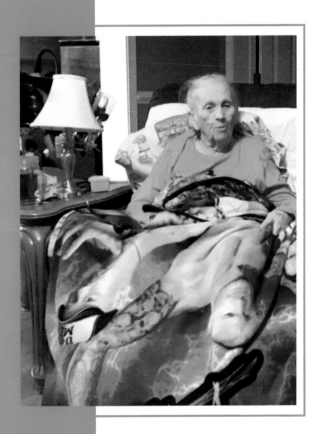

A STORY OF FAMILY AND FARMING:
Mildred Grigsby

Mildred Grigsby, at ninety-four, is a study in contrasts. Her petite frame dwarfed by a large recliner and wrapped in a blanket featuring one of the World Wrestling Entertainment's superstars, she's well-known in Colonial Beach for the delicacy of her crochet work, mostly done as she sat on the back of a truck while selling vegetables by the side of the road.

The needlework skill is something she believes her mother must have taught her at an early age, and it was

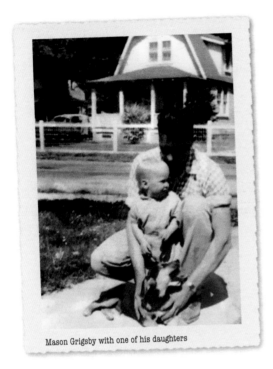

Mason Grigsby with one of his daughters

Mildred Martin had eight brothers and sisters, all raised on a farm just outside of town. She and one brother are the only ones still living. She and her husband, Mason Grigsby, had six girls.

"Any boy that came along would have been spoiled to death," she jokes.

The family's ties to the land go back a generation or more. Her parents had moved to the farm from Maryland before she was born. She went to Oak Grove High School, six miles from Colonial Beach, where many of the locals were bused for several years until the high school returned to the "beach." She recalls walking to school.

In another of those contrasts that mark her long life, she compares the solitude and hard work of farming with the excitement of a visit to the beach, even though it was only a few miles away. She remembers going to Colonial Beach

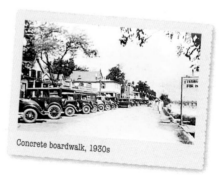

Concrete boardwalk, 1930s

something she took to that kept her hands busy as she sold those vegetables and raised her large family. Her beautiful doilies, tablecloths and table runners are prized possessions in homes all over town and a stark contrast both to that WWE throw and to the hardships of growing up working on the family farm.

"I think everyone must have at least one thing she crocheted," her granddaughter says.

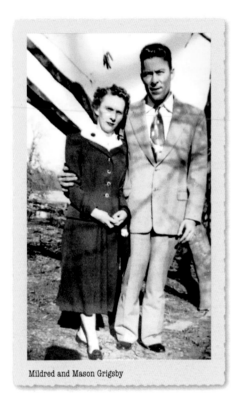
Mildred and Mason Grigsby

on the weekends as if it were an adventure far from home. It was certainly a far cry from the life on the family farm.

Back in the 1930s and '40s when she was a girl, the boardwalk wasn't a boardwalk in the traditional sense. It was made of concrete, and in fact, there was a street running along beside it. She remembers going to the Klotz store for penny candy. "They had everything you needed there," she says.

On the boardwalk in those days she recalls the bowling alley, the dance hall and roller-skating rink, beer places and bingo, a shooting gallery and, of course, the storefronts that sold snowballs, popcorn and peanuts. There were lunchrooms that sold hamburgers and hot dogs, too.

"There was a lot to do from May 30 till September," she remembers. She says she never went to the dance halls or pavilions, "but I loved to bowl."

In later years she even worked as a waitress in some of the restaurants along the boardwalk, and she can list some of her favorite places in town back then—Caruthers and Coakley drugstore. Mrs. Kennedy's ice-cream stand, the Emporium on Hawthorn Street, the old A&P and Wolcott's Hotel and Restaurant.

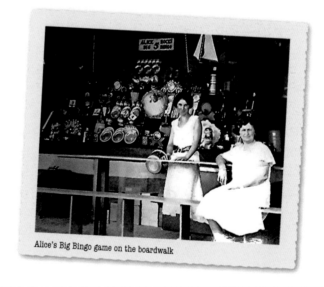
Alice's Big Bingo game on the boardwalk

When she married Mason Grigsby, they had the ceremony on Christmas Day. "He worked and I worked. I was on vacation. He worked at a gas station." Christmas was the one day they were both off.

She was working in a pants factory in Fredericksburg by then, along with several friends. For ten years they piled into a station wagon and made the trip to the factory together.

For years after that she worked as a waitress in the original Wilkerson's seafood restaurant at Potomac Beach, just outside of town. When that restaurant closed, she looked for something familiar to do, and it took her back in a way to life on the farm. She opened a vegetable stand along the side of the road on property that she and Mason owned.

"We grew some stuff, but mostly we bought from farmers' markets," she says.

Her daughter Shirley Hall adds that they would go to markets in Maryland and down the road in Tappahannock to buy vegetables throughout the summer. And while she sat by her truck selling those vegetables, Mildred crocheted.

By then Mason was working for the police department. From there he went to work at Cooper's, a store that claimed to "sell everything."

Mason was involved in anything in town that Bill Cooper asked him to do, Mildred recalls. He volunteered with the rescue squad and the fire department.

Eventually Mason began a carpentry business, doing the sort of work he loved. He even taught woodworking at the school. He worked at carpentry till he died.

All of her girls graduated from the school at the beach, married and stayed in the area.

"We're a close-knit family. We had to take care of Mama and Daddy," Shirley says. Those tight-knit ties were something Shirley's parents had taught them, lessons Mildred had learned from her own family.

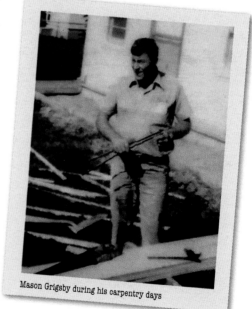

Mason Grigsby during his carpentry days

Shirley also recalls that she and her sisters were the cleanup crew when their father did his carpentry work.

"We'd go hunting with him and he'd have us barking like dogs," Shirley remembers. They hunted for deer, caught frogs and trapped muskrats.

None of that was as hard as farming, Mildred says. Her family raised corn, wheat and vegetables. They'd take it around by horse and wagon to sell. "That was before trucks." When they finally bought a truck, it was because "Granddaddy said we've got to give the horses a break."

The girls in the family didn't take the vegetables around to the customers back then. "Daddy declared it wasn't woman's work," Mildred says. "I used to think when I was sitting by the side of the road with that truck, I wonder what he'd think about this."

For all of the memories, though, Mildred is focused mostly on the family that surrounds her. She has a great-granddaughter and a great-grandson, who were both born on her ninety-fourth birthday.

The memories are nice, she says, but family is the thing that matters.

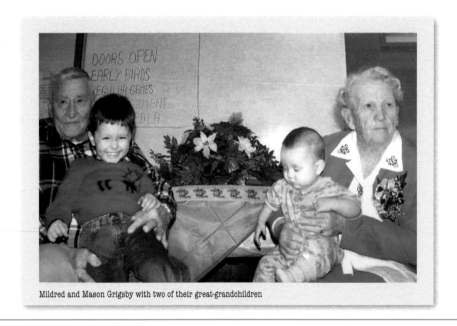

Mildred and Mason Grigsby with two of their great-grandchildren

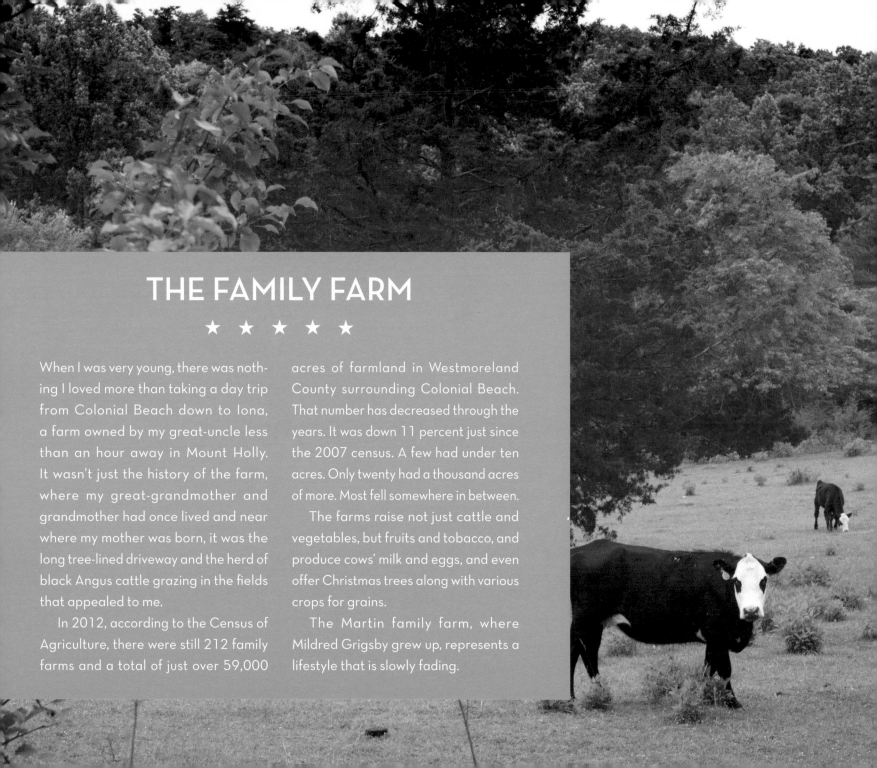

THE FAMILY FARM

★ ★ ★ ★ ★

When I was very young, there was nothing I loved more than taking a day trip from Colonial Beach down to Iona, a farm owned by my great-uncle less than an hour away in Mount Holly. It wasn't just the history of the farm, where my great-grandmother and grandmother had once lived and near where my mother was born, it was the long tree-lined driveway and the herd of black Angus cattle grazing in the fields that appealed to me.

In 2012, according to the Census of Agriculture, there were still 212 family farms and a total of just over 59,000 acres of farmland in Westmoreland County surrounding Colonial Beach. That number has decreased through the years. It was down 11 percent just since the 2007 census. A few had under ten acres. Only twenty had a thousand acres of more. Most fell somewhere in between.

The farms raise not just cattle and vegetables, but fruits and tobacco, and produce cows' milk and eggs, and even offer Christmas trees along with various crops for grains.

The Martin family farm, where Mildred Grigsby grew up, represents a lifestyle that is slowly fading.

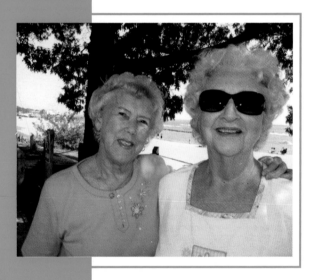

A LIFETIME OF FRIENDSHIP:
Jackie Curtis and Jessie Hall

Though one was born on Tangier Island and one was a Colonial Beach native, Jessie Hall and Jackie Curtis bonded in first grade at Colonial Beach Elementary School and have remained friends for decades. Their shared memories of growing up in Colonial Beach are good ones, rooted in the school they both loved, the men they married and the churches to which they belong.

Jessie, the daughter of a waterman, was born in 1930 on Tangier Island in the middle of Chesapeake Bay, but

came to the beach before starting school. Jackie, whose father was with the Virginia marine patrol, grew up right across the street from the school and remembers her fascination with watching the linemen when electricity was first installed. Her father was a patrolman on the river during the era of the Oyster Wars, and she recalls him finding bullet holes just above his patrol boat bunk during those wild days of confrontations on the water.

The two women laugh often as they tell tales from their childhood and from their teen years.

Jessie met the man who would become her husband, Donald Hall, in first grade, also. He was a year older. "He'd been kept back a year. He likes to say it was because the teacher liked him too much to let him go on to second grade."

The two women reminisce about spending all day with friends, riding bikes, roller-skating. "We just had to be home before dark," Jessie says. "Now you have to watch your children every minute."

Her father, like so many others in town, worked at Dahlgren, but also, like others, ran a sideline business

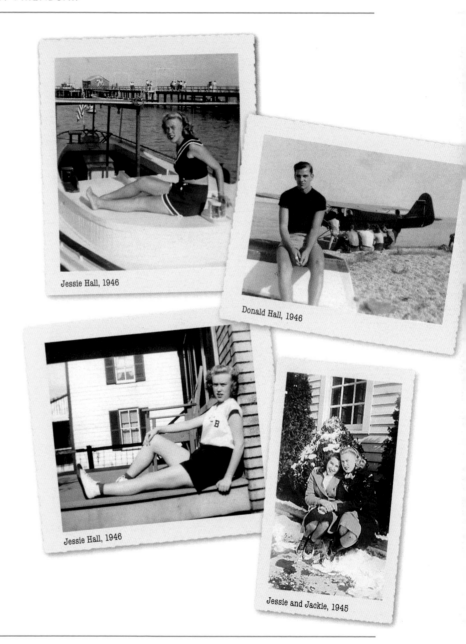

Jessie Hall, 1946

Donald Hall, 1946

Jessie Hall, 1946

Jessie and Jackie, 1945

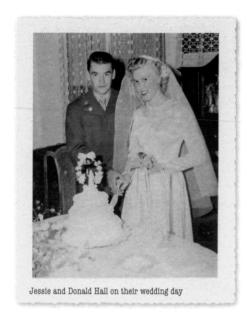
Jessie and Donald Hall on their wedding day

on the boardwalk during the summer months. He operated a shooting gallery on the boardwalk during the years when there were rides, casinos, a dance hall and a roller-skating rink. There was dancing and music at Joyland, and she and Jackie both loved music, "but our mothers wouldn't let us go there."

There was little question in Jessie's mind that Donald was the man for her. By seventh grade they were a couple. After graduation in 1948, he joined the army and served in Korea. They married on October 23, 1948 and had two children, Wanda and Donald Junior. After his military service in Korea, Donnie worked at nearby Dahlgren.

Jackie met Harley "Buddy" Reamy in fifth grade, and they went all through school and graduated together.

Three years later, he joined the army and was sent to Germany. Happy to be back home and away from the war, he said, "I don't care if I never go out the Beachgate again!"

Buddy later worked at Dahlgren and then opened a real estate office. They also had two children and had been married thirty-seven years when he passed away.

Ten years later Jackie remarried. Robert Curtis was from a much bigger town in Illinois, and she worried that he might not like small-town life. "But this is such a nice place to take walks, ride bikes and drive golf carts along the river," Jackie says. "Bob enjoyed this so much. He told me, 'I love it here.'"

A widow again now, she says softly, "I liked being married. I liked sharing my life with someone."

The two women recall their school days as if they were yesterday. They were "Drifters"—the name of the

Jessie as a hula girl

school mascot—through and through. They love the fact that their children went to the same school that they did and grieve over the wintry January night in 2014 when a fire—later determined to be arson—burned down the building where they'd attended classes and made so many memories.

One of their favorite teachers was Claudia Kitts. During her era the students performed Spotlight Revues, which were short skits or musical numbers. "Jackie, Donna Davis and I were the Andrews Sisters," Jessie recalls. Some of the lyrics were surprisingly risqué, they thought, still laughing about the fact that they were allowed to perform them.

For one number the girls wore costumes that included skirts made of crepe paper. "Eleanor Inscoe's fell off, and she ran off the stage," Jessie remembers.

What they remember most about Mrs. Kitts, though, is that they enjoyed learning. "We'd dance the Virginia reel or an Irish jig at recess. She made learning fun," Jackie says.

The town held a huge party for her when she retired in 1968.

Just because their own graduations and those of their children were long ago, it hasn't stopped their loyalty to the Drifters. Jessie and Donald still attend every high school basketball game and talk with pride about their championship runs and the year they brought home the state trophy.

But if the school played a part in their early friendship, they both say that their separate churches are important in the lives they lived back then and continue to live now.

Jackie grew up in the Methodist Church, which took over a building that once housed the Union Church, the town's first official church. It was used by various denominations for many years. One by one

Colonial Beach Baptist Church, 1961

Colonial Beach Methodist Church

Donald on the basketball court

the denominations built their own churches. The Methodists took over the building in 1911, and the building was later demolished. Jackie now lives in a home that was made, in part, from that scrap lumber.

Her mother played the organ at the Methodist Church, and she fondly recalls a community Thanksgiving service at that church in 1951. The service was followed by cinnamon rolls and coffee. "That made a sweet impression on me," she says wryly.

Meanwhile Jessie was a member of the Baptist congregation. "Our mother church was Round Hill Baptist Church," which is located several miles from Colonial Beach. "They started a mission at the beach." It began 120 years ago in a building on Bancroft Avenue across from the Hopkins store before moving to the main road in town, Washington Avenue.

She was two when she began attending services there and became a member when she was eleven.

Originally called the Colonial Beach First Baptist Church, members later realized that the African American Baptist Church had actually started earlier and gave them the designation of being the First Baptist Church. And when they tore down the church on Washington Avenue at the corner of Dennison to move to a larger building, they also gave their windows and pews to the African American church.

At one point, under Director of Music Steve Newman, they had several youth and children's choirs with eighty children. "Now we don't even have a children's choir," Jessie laments.

But both women see the churches as real anchors to the community for the members of their congregations. Many have food pantries, some have thrift shops; almost all hold events such as bazaars and dinners that draw neighbors regardless of their own denominations.

When asked about memorable characters in town, they mention everyone's favorite, Mattie Hopkins, who,

Jessie at the Bank of Westmoreland, 1948

with her husband, owned a small neighborhood store. It was well known for its jam-packed shewlves and for Mattie's willingness to turn a blind eye when it came to selling beer to young people without checking IDs.

Everyone seems to remember Mattie, walking to church in her tennis shoes with taps on them. Though she attended St. Mary's Episcopal Church, Mattie always stopped across the street at the Baptist Church, sat on the steps and changed into her "good" shoes before crossing the street to St. Mary's.

And, recalls Jessie, who worked at the Bank of Westmoreland for forty-four years, Mattie would always bring her store deposits to the bank tucked into her bra.

Mention the Bank of Westmoreland and Jessie's eyes get misty. "I hope I never see the day that building is torn down."

Standing on a corner in what was once the heart of downtown Colonial Beach, where the street was lined with crowds of tourists and locals every Saturday morning to shop at the A&P, the bakery or hardware store or to pick up mail at the post office, the Bank of Westmoreland, which was built in 1904, became Colonial Beach town offices for a time. The building was vacated several years ago, but many want to see it given the historic designation it deserves and used in some appropriate way to maintain the vital role it once played in the community.

Like so many others in town, the two friends lament some changes and embrace others. No matter what, though, neither would live anywhere else.

Donald and Jessie Hall

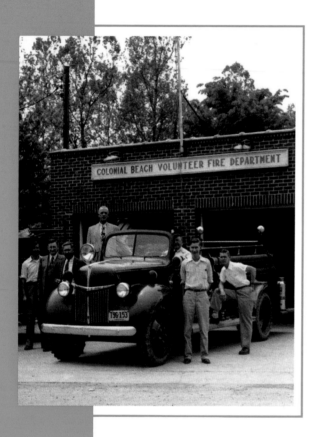

SERVING COMMUNITY AND COUNTRY:

Carlton Hudson and Pat Fitzgerald

On his eighty-eighth birthday with a pineapple upside-down cake awaiting him, Carlton Hudson sat in the Colonial Beach Volunteer Rescue Squad Building and reminisced, not just about his years of volunteering with the squad and the fire department but his military service, as well. Like so many others in town, he takes pride in having served his country.

With him on this morning is Pat Fitzgerald, whose volunteer record with the rescue squad has earned her

repeated honors locally and in the region.

"Sometimes I think I've seen more of Pat over the years than I did my wife," Carlton says.

His ties to the squad go back to 1950, when he can remember going on calls, when they had to dig in their own pockets to get gas money to run the ambulances to the hospital in Fredericksburg. Bucket drives in town to fund needed supplies or buy new equipment were the norm for many years, with the town kicking in some additional funding.

Pat, who's now retired from her career as a physical education teacher, driving instructor and coach in the schools, can remember being called away from school many times to answer emergency calls. She took calls at night, as well.

At one point, while Carlton was driving a truck for Norman Oil, he got an emergency call and ditched the truck on the side of the street so that he could shift into volunteer mode and handle the emergency. The passing fire truck stopped so he could jump onboard.

Eventually employers tired of losing staff to these volunteer duties, and the town and county combined to bring in paid workers. Staffing for both the fire department and the rescue squad continues to be supplemented by dedicated volunteers, with each group supported by active ladies auxiliaries who do their share to see that funding needs are met.

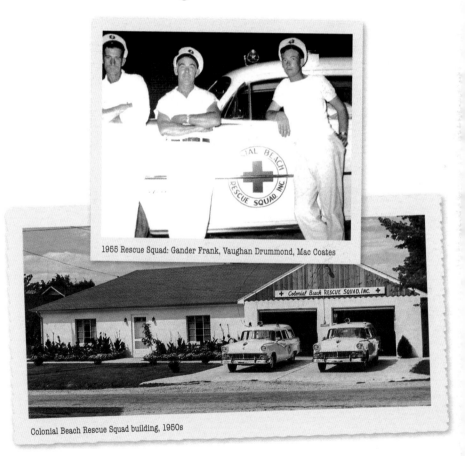

1955 Rescue Squad: Gander Frank, Vaughan Drummond, Mac Coates

Colonial Beach Rescue Squad building, 1950s

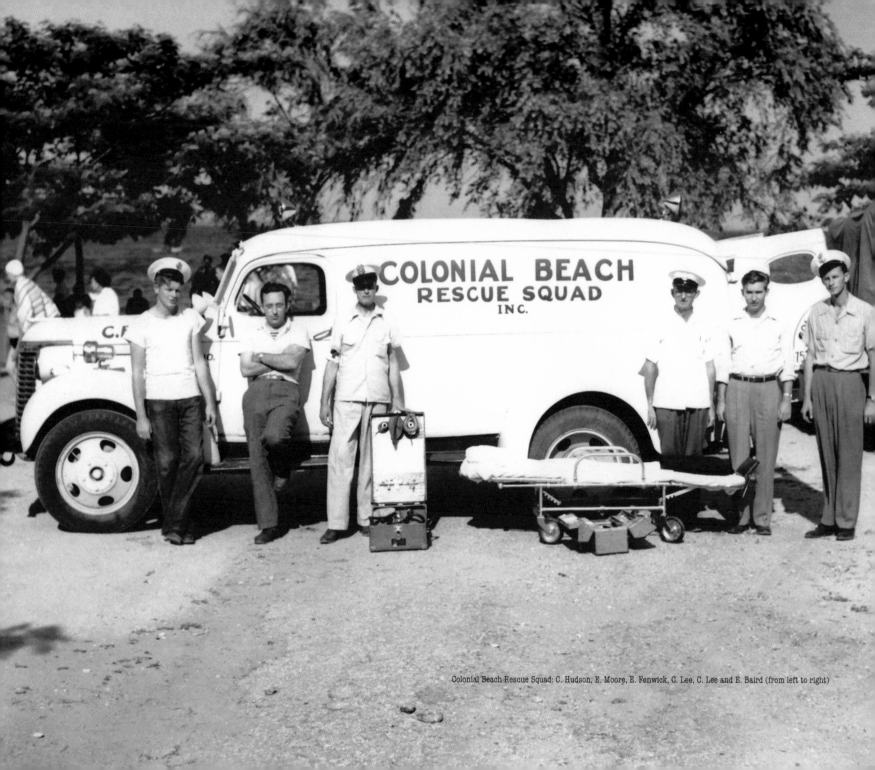

Colonial Beach Rescue Squad: C. Hudson, E. Moore, E. Fenwick, C. Lee, C. Lee and E. Baird (from left to right)

Carlton and Pat both admit it's not always easy taking calls when the emergency involves people they know well in the community. Pat recalls going to the scene of a fire at Carlton's house, in fact, and racing around to the back of the house to show firefighters where to find her longtime friend.

"All Carlton could talk about was the fact that he wasn't dressed," she remembers. "I just kept telling him we had to get out of there."

Hospital workers are always pleased when the volunteers come in with a patient, she says. "Often we know their history. That's the positive side of it."

But if Carlton is proud of the years he spent taking calls and driving the ambulance or a fire truck, he's even more proud of the years he served in Korea.

He was assigned to the motor pool. "If one of the jeeps broke down, I was sent to deal with it."

He remembers a staff meeting in which his first lieutenant stood up and announced Carlton would be taking over the motor pool. "Two months later he called me back in and said it was in better shape than it had been in years."

Not only had he kept the equipment in top working

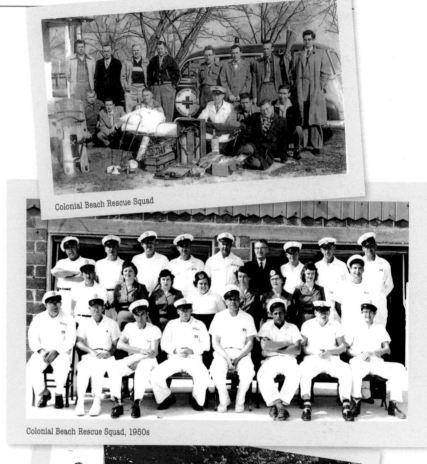

Colonial Beach Rescue Squad

Colonial Beach Rescue Squad, 1950s

Colonial Beach Rescue Squad, 1969

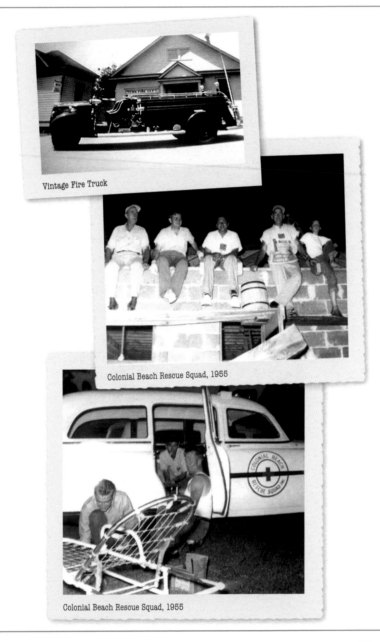

Vintage Fire Truck

Colonial Beach Rescue Squad, 1955

Colonial Beach Rescue Squad, 1955

condition, he'd improved the record-keeping, too. "I had four of the best mechanics you could find and the best generator man. We got that motor pool straight," he says proudly.

At one memorable inspection, he recalls that though they did pass, points were taken off for one thing. "There was grease underneath our fingernails."

On one occasion, he felt a tap on his shoulder and turned to find General Dwight D. Eisenhower. "I shook hands with President Ike," he says with a sense of wonder.

When he was promoted to sergeant, he told his superiors they were "moving too fast for me."

At one point during the war, he crossed paths with the son of Captain Joe Miller, the Colonial Beach police chief. A lieutenant colonel, Miller suggested Carlton stay on and serve as his chauffeur. Carlton declined, so he could see the job he'd started with the motor pool through to the end.

His brother started his own tour of duty in Korea just as Carlton's finally ended, and he came back to Colonial Beach.

Back home he officially joined the Colonial Beach Volunteer Fire Department and once more continued his involvement with the rescue squad.

His full-time job by then was working for the Norman Oil Company, owned by George S. Norman. Carlton was there for thirty years, and, as it had in the military, his reliability paid off.

"Mr. Norman had racehorses, and he liked to go to the track to check on them and watch the races." Carlton called him one day at the track about a problem.

"I called Mr. Norman my second daddy," Carlton says. When Mr. Norman came home to resolve the problem, part of his solution was to have Carlton's name added to the company checks. "He told me, 'If you need something, you buy it. Just don't ever call me at the track again.'"

From that time on, Carlton managed the company, which was located at State Road 205 near Wilkerson's restaurant. "We dealt with Mobil Oil," he recalls. "The product came by boat. We had to wait for high tide so it could get in there."

Class trip to the firehouse, 1950s

Colonial Beach Rescue Squad, 1980s

Colonial Beach Fire Department, 2015

He took one of the drivers down to Richmond to look for a new truck. The driver was drawn to a big Mack truck with lots of chrome on it. Carlton got the salesman to "sharpen his pencil" and make a better deal, then he bought the truck.

The next time Mr. Norman came by, the driver was worried about the expensive purchase.

"He said, 'Mr. Norman's going to jump all over you,'" Carlton recalls. "I told him, no, he's not."

Mr. Norman spotted the truck right away. "Where'd you get this?"

The worried driver jumped to his boss's defense. He didn't need to. Carlton stood up for himself to the man, who was seldom around from May through December.

"I told him, 'You don't realize we're a big oil company now. There are people who want to take over.'" He showed him the company checkbook, detailed the changes he'd made, the routes he'd expanded. He showed his boss every expense and every bit of income itemized. "I told him, 'I've built you a big business.'"

Mr. Norman wanted details about the staff and what each of them made, information Carlton readily supplied. "The next time he came in he had a big suitcase full of money, and began to hand out bonuses. He gave me $1,500, one of the drivers $900, others $500. He gave $200 to the girls in the office. He said one of his horses had come in."

Though there were offers to buy out the thriving business, "he never would sell," Carlton says. After he died, it was finally sold off. "If I'd been younger, I'd have bought it," he says.

Just as he felt a personal kinship to George Norman, Carlton and Pat both feel as if the Colonial Beach residents are more than a community. "We're one big family here," Pat says.

Like all families, there are occasional squabbles, but in the end, in a crisis, everyone pitches in, and dedicated volunteers like these two are the glue that holds much of it together. Pat, who'd coached at the school for years, was recently honored for that work and so much more. One of the ballfields was renamed Fitzgerald Field, a surprise that deeply touched her. Like so many who give so much to the town, the reward for her is in the giving, not the recognition.

Colonial Beach Fire Department building, 2015

CHANGING TIMES:
Burkett Lyburn

Burkett Lyburn was born during a transition era for African Americans in Virginia history. Schools in the state were slowly desegregating, but there were still signs of discrimination in other ways.

Born in Lancaster County, not far from Colonial Beach, to a father in the military and a mother who taught school, he can recall times when he'd go with his father to a café window to pick up food because they weren't allowed inside, times when they had to use a

different bathroom in public places. "My dad was very cautious. He played by the rules," Burkett says, recalling that he struggled to understand those rules.

After Lancaster County, they lived for a time in Baltimore, which he remembers as "a go-go-go" kind of place. He was twelve by the time his father was transferred to the Dahlgren Naval Surface Warfare Center, and they settled in Colonial Beach, which had a slower pace that better suited him.

By then it was 1966, and the schools at the beach had integrated. There was no longer a separate school on Lincoln Avenue for black children.

"I think it was a smoother process, perhaps, because everybody knew everybody. Kids in town played together, regardless of race."

Even so, Burkett remembers that when he first moved to town, he was told he couldn't swim on the main beach; that he'd have to swim down at the Point. His friends promptly dismissed that.

"They'd say, 'Come on, let's go.' It evolved because we were friends."

Like so many of the youngsters of that era, he remembers the train ride on the boardwalk, the bumper cars, the water slide and the town pool.

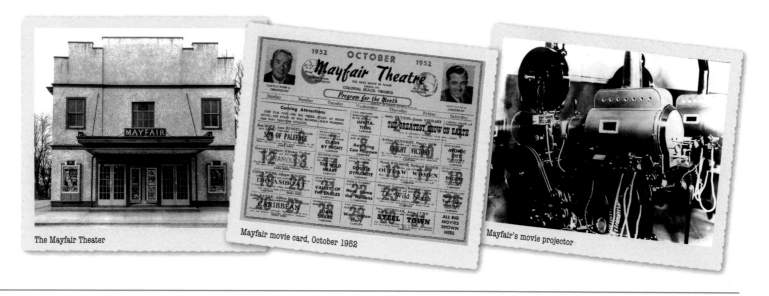

The Mayfair Theater

Mayfair movie card, October 1952

Mayfair's movie projector

His dad bought him a lawn mower and suggested he make his own money. He worked for a time at Cooper's, the business known for "selling everything," but his best memory is of working at the Mayfair Theater on Washington Avenue, just down the hill from the school. He was a projectionist there. "We'd get in new movies on Monday and show 'em for two or three days, then ship 'em back out and get a new one."

Tickets back then were three or four dollars, popcorn a dollar, a drink fifty cents and candy twenty-five or fifty cents. "You could take a date to the movies for fifteen dollars."

"When the theater burned down [in 1972], it was a sad day for us." He remembers watching the fire from the humongous windows at the school and wanting to go down to help fight the flames. "We were told we couldn't go until they'd knocked the fire down."

Just like that, his job was gone.

Burkett had plenty of things to fill his time back then. "I was into music. I sang in a lot of talent shows. I was usually singing three or four times a year in

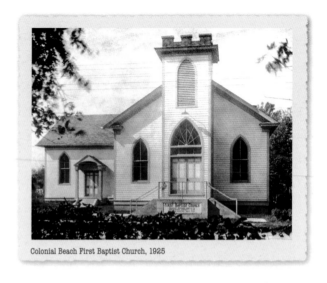

Colonial Beach First Baptist Church, 1925

something, talent shows, homecoming dances. There were a lot of activities."

He still loves gospel music and continues to pursue it. In fact, he met his wife at a gospel concert. "She likes to sing, but she's kind of bashful. I'll get up and sing anytime."

He's sung for forty-two years at the First Baptist Church—the town's oldest established church, which started in 1892, the same year the town was founded. At one time the membership there was around three hundred people, but some have moved away. Some

members live out of town, he says, but return for services on Sunday morning. Children, if they come at all, it's with their grandparents. It's a change many churches in town are seeing.

Burkett has had his own quartet for forty years, the GospelAires as well as the All Together Gospel Singers. He's performed with some of the greats in gospel music and has a CD. He likes the balance of music with his own post-military career in transportation services in Washington. The long commute, which he's dealt with for many years, is something he shrugs off, the price of getting to live in a community he's considered home for so long.

Besides, he says, when it comes to music, "when you have kids, you can't go on the road. You're missing all that time with your children. In the gospel field, you'd have to perform four or five times a week to make a living."

He has six children, now scattered all over. His oldest daughter

lives in nearby King George County. "My baby is in college," he says. "She wants to be a lawyer." One daughter has followed in his mother's footsteps and works as a special education adviser for home schools in Maryland. Two sons followed his path through the military, and the third works in IT at Dahlgren.

"One's a bookworm. Another's all about making money. One loves to sing. The boys can sing, but won't," he says ruefully.

He wishes that Colonial Beach was the draw for all of them that it has been for him, his wife and his parents, who also continue to live in Colonial Beach. Part of his mission on Town Council, where he's serving his second term, has been to find more activities to keep young people in the area.

Economic growth is something that concerns him, too. He filled a vacant seat on the Westmoreland County Board of Supervisors before running for town council at the beach. "It was a good learning experience," he says. "And around here, if you're wrong, they'll tell you."

The path for him in local government was paved by Charles Garland, Colonial Beach's first African American mayor. The former mayor was elected in 1980, nearly a century after the town was incorporated.

Trying to balance the reality that the town has become something of a retirement community with the costs of its infrastructure needs is a challenge, Burkett says thoughtfully. "We need to encourage business to get that money. We have to think outside the box."

He'd like to see more incentives to encourage businesses to start. Those incentives matter when a small business owner's cash is tied up with getting the business up and running, he explains.

During his childhood years when his dad relocated with the military and during his own years of service, Burkett says, "You travel. You learn a lot and meet a lot of different people. The military is a big family."

In the end, though, he, like so many others, got sand on his feet. "I love being around water, and I love my little town."

RIGHT SIDE OF THE LAW:
Michael Mayo

Attorney Michael Mayo has a passion for several things—the law, the town of Colonial Beach and the woman he met back in the '70s when he was studying law at the University of North Carolina.

Though there are a lot of Mayo families in Westmoreland County, his father, John Mayo, was actually born in Lewiston, Maine, one of eight children in a poor family, Michael recalls. "The boys in the family started going to college. My father ended up at the George

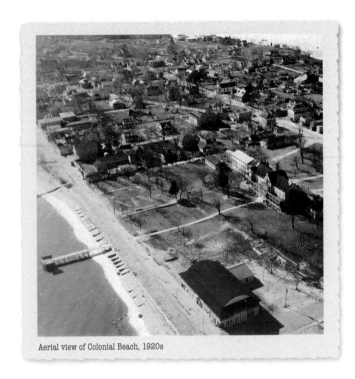

Aerial view of Colonial Beach, 1920s

an oysterman himself for a couple of years and had a bit of a drinking problem. He quit drinking in April 1946. It was the month Michael was born, and that was the likely motivation for him getting his act together, Michael believes.

"He had a golden tongue," Michael recalls. "People would drive down just to listen to him in court."

Because his father had a successful career as a small-town lawyer, Michael remembers having a "blissful" childhood in Colonial Beach. "We rode our bikes everywhere. We knew all our neighbors. School was good. I liked learning."

There were some racial issues at the time, he recalls, echoing Burkett Lyburn's memory. Others have recalled that there were tensions and protests at the time. Schools were integrated during the years he attended, which caused some strife, and African Americans were not expected to go south of Boundary Street unless they worked for a family in that part of town. In his own family, though, their housekeeper was considered a part of the family. When he was married in Ohio, she was right there with them for the festivities.

Washington University in Washington, DC, then went to Georgetown Law School, graduating in 1932."

Because he met and married a woman from this area, John Mayo settled in Colonial Beach and opened a law practice, defending, among others, some of the local oystermen who got caught up in the Oyster Wars on the Potomac in the 1950s. He also worked as

He admits that the small Colonial Beach school had its limitations, limitations he wasn't aware of until he went away to college and compared his educational background with others. Despite the less extensive classroom opportunities in diverse subjects, he remembers fondly the math teacher he especially liked, Mrs. Virginia Ford, and talks with pride about the basketball team that made it all the way to the state championship and lost in the finals. His graduating class was only twenty-four students.

His father told him he could go to college anywhere he wanted, so he chose a big city and went to the University of Miami to expand his view of the world. He spent two years there in a dorm and two off campus in an apartment near the Orange Bowl stadium. With Miami's large influx of Cuban exiles fleeing Castro at that time, he had his first significant exposure to another culture.

It was during those years in Miami that he made his decision to follow in his father's footsteps and study law. "Once I'd decided that, I knew I wanted to work for myself."

From Miami, he went to law school at the University of North Carolina, where he met Valerie Jean Powers, the woman who was to become his wife. An Ohio native, she was in graduate school studying library science.

"She thought I was babysitting her for another man," he recalls. It was months later before she realized they were actually dating.

At the time both he and his housemate were studying law. Valerie would come to dinner, and the two of them would essentially dismiss her from their conversations. "We thought we knew everything," he says wryly. "She decided to go to law school, so she'd know everything, too."

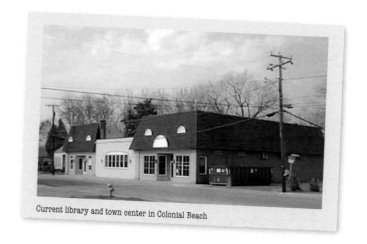

Current library and town center in Colonial Beach

Though she, also, has had a successful law career in the county, she continues to have "a great love of libraries," he says. Among her passions was working to see a central library system for the region become a reality. Colonial Beach's Cooper Branch is now part of that Central Rappahannock Regional Library System.

Michael's father died when he was in his first semester of law school. By then Michael knew he wanted to open his law practice back home in Colonial Beach.

He started out practicing a little bit of everything from criminal defense to estate law. "I was a standard country lawyer," he says.

He handled the legal work for some of the property developments around town and remembers when there was nothing but a little dirt road outside of his office "from here to the river. A salesman flew in and landed on the street. He was charged with reckless flying."

Over the years he honed his practice and began concentrating on estate law.

Now in his early seventies, Michael likes some of the building changes he's seen in town through the years, whether it's big houses or little cottages. "There's money coming into town. We're making ourselves known."

Michael Mayo fishing

It's happening, he says, because of the natural beauty of the area. "The water's not deep, but it's nice. It's what we have to offer. I still water-ski. I started when I was twelve. I can still get up on one ski," he says, then laughs. "It's not pretty, but I can do it."

And yet, despite the changes and growth, he sees the small Colonial Beach community retaining one of the things that drew him back home. "There's that strong sense of connection with people here." Because of that, coming home is something he's never once regretted.

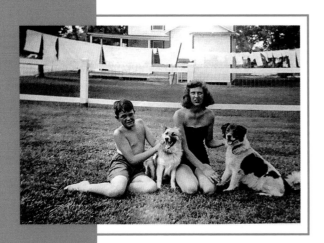

A WHOLE DIFFERENT WORLD:
The Sydnors

Whether it was back in the mid-1900s or in 2016, one unifying thread for people who've found their way to Colonial Beach from Washington, DC, Northern Virginia or any other big city is that this little town on the Potomac River is "a whole different world."

No one is able to describe the differences better than the Sydnor siblings, who grew up in Washington, but spent their summers coming to Colonial Beach and staying in the house their father built in the

late 1930s. They eventually retired to the town they loved.

Edna Edmondson is the oldest of the three, Luke is the youngest, which puts Betty Wilson smack in the middle, "where I really suffer," she jokes.

The story is told that if their mother "hadn't been in such a hurry to make the ferry," Betty would have been born in Colonial Beach.

Once the three of them start reminiscing about Colonial Beach, the stories and laughter don't stop

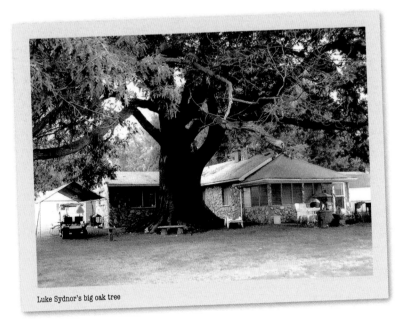
Luke Sydnor's big oak tree

for a minute. Neither do the occasional tears as some memory or another strikes a particular chord.

Their parents first came to Colonial Beach as a young couple and their dad started building a house for the family in the late '30s or early '40s. In their yard was a big black oak tree, estimated to be over 250 years old, that was the family's pride and joy. There were stories that Robert E. Lee had once sat under that very tree as a child. Betty and Edna recall sitting under the shade of that tree to read or play. Out of respect they didn't climb it. Around town it was admired for its historic age and spreading branches. And when it was eventually felled by Hurricane Isabel, there were tears shed.

So many of their best memories are tied to this town, to building and to growing up during carefree summers here. They learned to cut grass with a sickle and to use rakes to deal with the thousands of leaves from that big old oak.

Edna recalls helping her father sand boards as he built the kitchen. Luke remembers mixing up rock salt and water to kill the weeds. "That was our Roundup," he says.

At one point, with their father using every spare minute to work on the house, they remember him being cited by Captain Joe Miller, the police chief, for working on a Sunday, which was against the state's "blue" laws at the time.

Edna learned to drive a car at the beach. "But she couldn't get it in Reverse," Betty taunts. "She threw Luke and Daddy into the front. Luke hit the mirror."

Their parents had planned to retire to the beach. Sadly, though, their father died on June 19, 1964. He was set to retire on July 1. Though he'd spent many a weekend working on the house, he never had the chance to live in it full-time.

"Back then everybody knew everybody by name," Edna says. "And they knew your mother." Which meant that any mischief, no matter where it happened, was likely to be reported right back to your parents.

People walked places or rode their bicycles. "Luke, as the baby brother, had to be watched over," she says. They'd walk to Denson's for kerosene for the stove or groceries. They walked to the icehouse to get a twenty-five-cent block of ice, and pulled it home

in their little green wagon. They used that ice to make ice cream in an old churner.

"We made quite a bit of ice cream. That was the most fun," Edna recalls. "Our mother would tell us there was no need to discuss who would get to lick the paddles—that was her decision."

Though the children went to retrieve the ice, many items were delivered house-to-house in those days. Farmer's Creamery from Fredericksburg delivered milk and Charles Chips would bring potato chips.

One of their favorite local door-to-door produce salesmen in that era was Joe Roy. He was an African

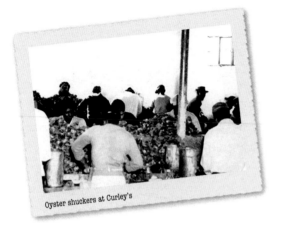
Oyster shuckers at Curley's

American Baptist minister who lived out in the nearby countryside and farmed. He would come around with a team of horses, selling produce. They especially loved the watermelon and cantaloupes. "He'd take a plug out of the watermelon so the customer could taste it," Luke says.

"I thought that was so neat," Luke adds. He'd spend over four hours riding through town with Mr. Roy, while the man's grandson, Dallas, would ride along beside the wagon on Luke's bike. "I'd drive the team of horses."

"Mr. Roy never came to the front door," Edna remembers. If he and Dallas were invited to join the family for a meal, it was served on a picnic table in the backyard. It was a sign of the times that they didn't feel comfortable coming inside.

Even so, the families were so close that when their father died, their mother gave Mr. Roy his clothes, Betty recalls, choking up at the memory.

Though they had a lot of freedom in those days, Luke was very firmly instructed to stay away from Curleys' oyster packing plant and the store where the rough-and-tumble oystermen hung out. He was told "it was not a place for youngsters." That didn't stop him.

He loved watching the African American shuckers working. "They'd sing gospel music and get this rhythm going. I'd stand there just to listen. We didn't have recorders then, but I wish I'd been able to record it."

There was almost always someone who'd pop the top off a bottle of soda and hand it to him as he listened. He'd nurse that Coke as long as he could.

The boardwalk was the liveliest place in town during those days. There were several open-door bingo parlors with gaudy prizes on display. The sound of people calling out "Bingo," echoed outside. At that time, players marked their cards with kernels of corn, rather than the markers used today.

Luke and his friends also made a little money "reserving" benches for the grown-ups who liked to sit along the lively boardwalk and watch people. "We'd lay down on the benches until our customers came along. They paid us twenty-five cents for holding a bench for them, and we'd go off and spend it on something."

The Sydnor siblings remember remember the workboat races on Monroe Bay, when boats mostly owned by Mr. Curley, Pete Green and George Townsend competed. There was a ski club that did shows on the bay.

"They didn't have the money for fancy boats or costumes," Luke recalls. "But everything they did at Cypress Springs in Florida, they did here. People made donations to help them out."

They speak longingly of the Panzer bakery and the aroma of the rolls, especially on a Sunday morning. Luke recalls that his friend Sugie Green, who married oysterman Pete Green, worked at the old A&P as a cashier. "They had a big old manual cash register. I'd be mesmerized by that," he says.

They all lament that so many of those old ways have been lost. "We claim to be tourist-friendly, but we're not," Luke says with a deep sense of regret. "We claim to be business-friendly, but we're not."

All three of them have taken active roles in their adopted town over the years. Luke attends almost every Town Council meeting. He's worked with the Chamber of Commerce on events. Edna belongs to the Colonial Beach Historical Society. Betty participated in many of the Potomac River Festival parades as a clown.

Betty recalls the days when the beach was known far and wide as the Playground of the Potomac. "A summer population explosion happened then," she says. "But there was such serenity, such joy, such comfort" in days gone by, Betty says.

And while some of that may be missing now, their love for the beach remains strong and their ties here deep. Not a one of them shows any signs that they're ready to stop fighting to make it that way again.

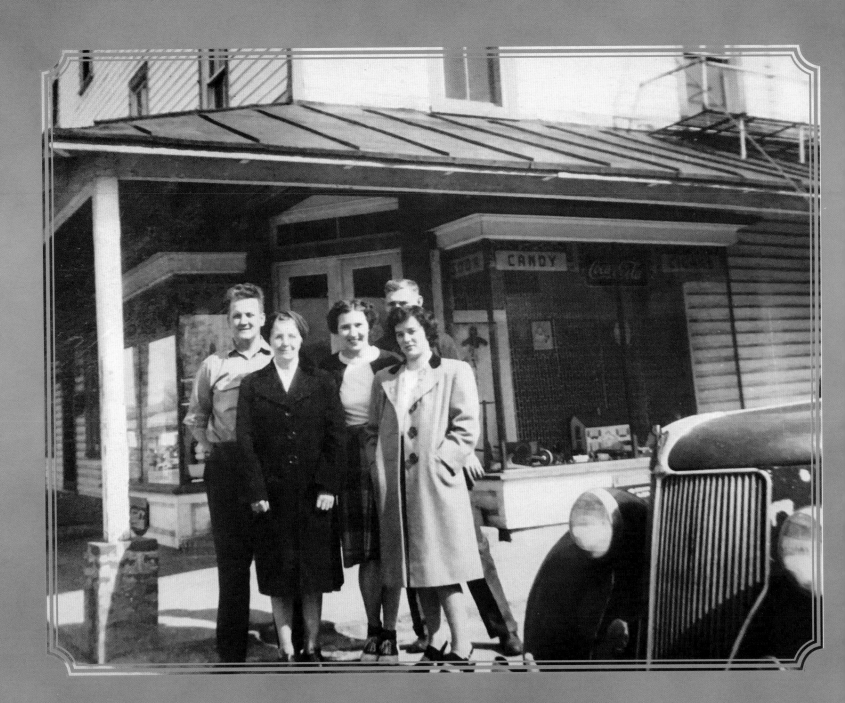

A Loaf of Bread, Penny Candy...and Freedom

Growing up along a very busy road—Fairfax Drive—in the bustling Ballston area of Arlington, Virginia, there were a lot of cautions and restrictions in my life during my early years. But in Colonial Beach, with its quiet streets and slower pace, a walk to Mrs. Sullivan's, a tiny neighborhood grocery store, all by myself or with friends, was an indelible summer memory, a rite of passage.

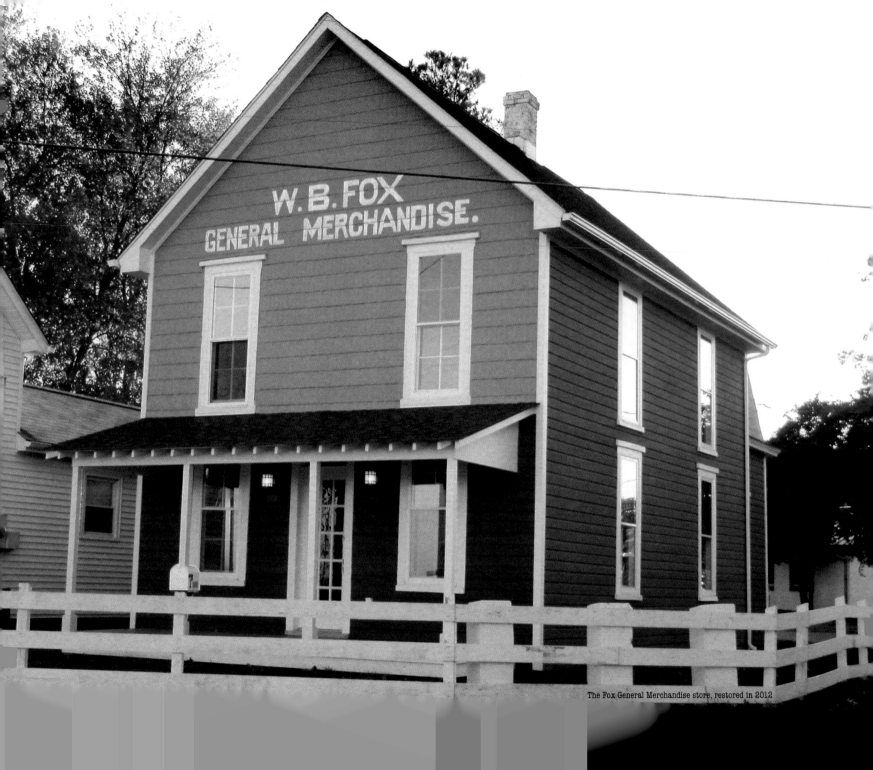

The Fox General Merchandise store, restored in 2012

Mrs. Sullivan's, which was probably no more than a twelve-by-twelve room with crammed shelves filled with basics, was only two blocks away. I could be sent there alone for a loaf of bread or go with other youngsters to get an ice-cold soda from the big red Coca-Cola cooler or a Popsicle on a steamy, hot afternoon. It gave me a remarkable sense of freedom at a very early age. I still get a twinge of nostalgia whenever I pass by that building, though it no longer houses a business.

I was not alone in seizing this rare opportunity. Among the many memories shared by others in this book were their visits on foot or on bicycles to the neighborhood grocery stores close to their houses, stores that dotted the landscape of Colonial Beach in those early days when cars were few or only to be used for long-distance, "important" travel.

Though the entire town covers just a few square miles, in one small area alone there were stores owned by Mattie Hopkins, Oliff's near the water tower, another one that primarily served the oystermen at Curley Packing Plant and, perhaps the longest-lasting of all, Denson's. One statistic indicates that in the 1920s

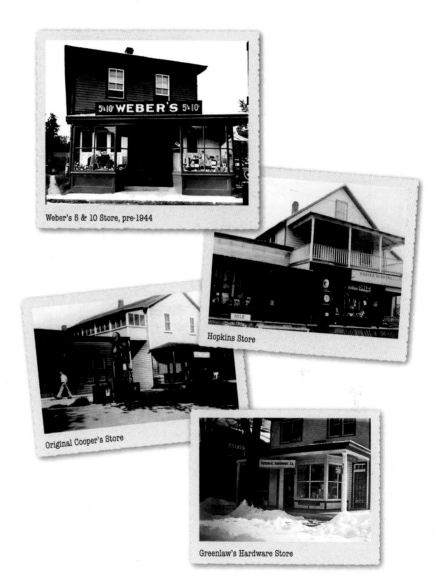

Weber's 5 & 10 Store, pre-1944

Hopkins Store

Original Cooper's Store

Greenlaw's Hardware Store

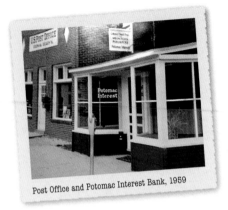

Post Office and Potomac Interest Bank, 1959

there were nine bars in this town of some three thousand or fewer residents and seven grocery stores.

But if going to one of these tiny neighborhood stores, each with its own distinct personality thanks to its unique owner, was a rite of passage, so, too, was a trip to Klotz's. While the store stocked a wide variety of merchandise, as a child I always gravitated straight to the penny candy, as did most every other child in town, adhering more or less to a strict no-touching rule.

That memory is so clear in my mind that those of you who've read my *Chesapeake Shores* series will recognize that Ethel's Emporium, with its colorful display of treats, is very much based on Klotz's, as is Mick O'Brien's habit of always having penny candy from Ethel's available for his grandkids. I'm pretty sure it was my grandparents who indulged my sweet tooth more often than my parents did. (And on a side note, I know it was my grandfather who introduced my cousins and me to the old diner that sat on the corner of Colonial and Washington avenues and the particular joy of going out for an early morning breakfast.)

These small stores have mostly closed over the years, making way first for an A&P and now for 7-Eleven and Food Lion. It was the arrival of a national chain of five-and-dime stores that ultimately drove Klotz's out of business. The family-owned Hall's store still operates just outside of town as a full-service grocery store, but Denson's is perhaps the most unique in the ways it has reinvented itself over the years.

Marguerite Staples, whose family owned Klotz's, recalls her family's history in town, her own years of trying to keep the store in business and the memories that people continue to share with her.

Rocky Denson, who created the latest incarnation of the family business in a former ice-cream and pizza shop along Colonial Avenue, is at least the third generation of his family in the grocery business in Colonial Beach. He came to the business reluctantly and belatedly, but has made a thriving, award-winning success of it.

Here are their stories.

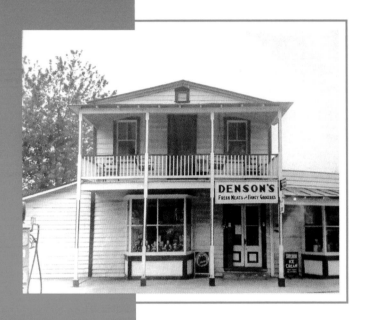

A LONG LINE OF MERCHANTS:
The Densons

In its early days, even a town as small as Colonial Beach had family-owned grocery stores in just about every neighborhood. Each one had its own unique personality, but none endured, adjusted and reinvented itself in quite the way that Denson's did.

"We came from a long line of merchants," says Rocky Denson, the newest generation to supply food and delicacies to residents of the town.

It was his grandfather, Frederick LeGrand Denson, who first came to Colonial Beach from Maryland in 1911. Not only did he open Denson's grocery store in 1912, but he also had an oyster-packing plant—the Marva Oyster Packing Company—located near the Stanford Marine Railway. Workers earned chits for the oysters they shucked. At one point he also had a tomato canning factory in nearby King George County.

When Rocky's grandfather died in the '30s, his grandmother, Jetta Denson, took over running the store. Even after his dad enlisted in the navy during World War II, he was stationed in Norfolk, close enough to be able to come home on weekends to help in the store.

Mayor Boozie Denson

His dad and Bill Cooper, whose family owned Cooper's, which sold a little bit of everything, from clothing to hardware, were best friends, Rocky recalls. Seeing that his buddy had remained close to home while serving in the military, Bill Cooper also went down to enlist, but unlike Rocky's dad, he was shipped overseas.

Ann Denson

"My dad was a signalman. One day they received sealed orders to go to Hampton Roads to greet an incoming ship, the USS *Iowa* battleship coming home from sea duty. On the deck, Dad kept thinking he heard his name. He finally looked up and saw Bill Cooper leaning over the railing of the *Iowa*."

Suffice it to say, Cooper had a few sharp swear words for his friend who'd convinced him to enlist thinking he, too, would stay close to home.

Not long after his navy tour ended, Rocky's dad met the woman he would marry. She was a nurse's

assistant at Mary Washington Hospital in nearby Fredericksburg, and she was caring for Rocky's grandmother.

They married and built a new, bigger version of Denson's across the street from the original store. Rocky, who was born in 1956, recognized early on just how hard the work was. Today, though, he says those are "memories I wouldn't trade for a million bucks. My dad would be working back at the meat counter, and he'd decide to take a break and we'd go fishing."

Rocky was the baby of the family. He had two older sisters. Jetta had multiple sclerosis and passed away a few years ago. Carol Ann still lives at the beach, and when Rocky first decided to open yet another version of Denson's, she worked with him to get it established.

Ironically, Rocky, whose real name is Bernard George, decided early on that the grocery business wasn't for him. He went away to college, but continued to spend summers at the beach working as a lifeguard.

He vividly recalls one particular summer when he and two of his boyhood friends—Steve Swope, who

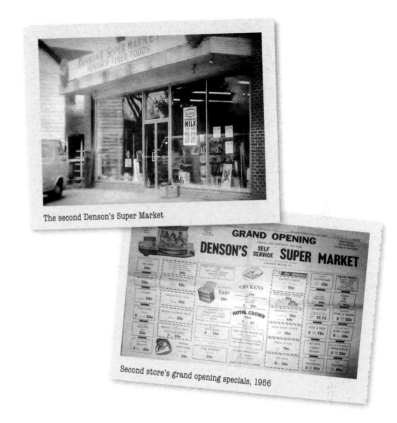

The second Denson's Super Market

Second store's grand opening specials, 1956

later became the town's most celebrated basketball coach of its championship team, and Mark Green—worked as lifeguards together.

"Walter Parkinson would come to the fishing pier first thing in the morning and turn on his loudspeakers

to start announcing fishing charters and boat rides," he recalls. After a night of partying, the three young men would groan at the sound.

Rocky says he arrived late one morning to see his two friends standing on the town pier watching as Walter started his morning ritual. But when he made his announcement, there was no sound. Walter tapped the microphone, fooled with the equipment and finally discovered that the speakers had disappeared.

Walter and another captain, Donald Markwith, searched the water and anywhere else they could think of, looking for their missing speakers.

Months later, Markwith dropped in to visit his friend, waterman Pete Green, Mark's dad. Pete was in his garage making oyster stew.

"Donald goes in and spots something he hadn't expected to find. 'Those are my speakers,' he told Pete."

Rocky laughs, but winces as he tells the story. "Do we have to use names?"

Then he adds that back in the day that was the sort of mischief kids got into. "We did pranks. We didn't get in real trouble."

He recalls all the things there were for young people to do on the boardwalk—Davis' shooting gallery, Millie Mears's snowball stand, the Black Cat, which had live bands for kids. "It didn't serve alcohol. It was painted black and had black lights. It was really neat."

Rocky also recalls that his father, known in town as Boozie Denson, was active in politics. "He and Gordon Hopkins sort of alternated running for mayor over a period of twenty years." The two men were good friends.

"One time Gordon came by the store because he'd heard Dad was thinking of not running. He said, 'Boozie, if you're not going to run, will you endorse me?'"

His father agreed, then later decided to run after all. Rocky's mother, Ann, was appalled. "She never wanted to be involved in town politics in the first place."

She saw what her husband was doing to his friend as a betrayal and told him flatly, "I'm not voting for you."

On election night people gathered late into the night outside the old town hall as the votes were tallied. "It was 2:00 a.m., but people were riding around town, beeping their horns. Gordon had beaten my dad."

Third generation of Denson's Grocery, 2013

His dad made a traditional concession speech, thanking those who voted for him, praising his opponent and saying that Gordon would make a good mayor, then added, "And Ann would like to thank everyone who didn't vote for me."

Rocky believes it was a simpler time back then, at least when it came to deciding what was best for the town. "People respected each other. Nobody yelled and screamed. Everybody had passions and emotions, but it was important to be friends at the end of the meetings."

Denson Family today

Rocky has no interest in getting involved in town politics as his father did and for years couldn't imagine following in his parents' footsteps in the grocery business, either. He worked in financial services and spent most of his career with the Farm Bureau.

It was during his tenure there that he met the woman who would later become his wife, Blaire, at a Farm Bureau event in Florida. They sat together by chance at a crowded convention session and were encouraged by their kids from previous marriages to spend more time together.

When the convention ended, she went back to North Carolina and he came back to Virginia, but they continued to meet in Emporia, partway between their hometowns, whenever they could and eventually married.

"During my last five years with the Farm Bureau, the only thing I could think about was reopening Denson's Grocery," he says, acknowledging the irony.

With Blaire's encouragement and help from his sister, who made the family's chicken salad for the deli and helped with a million other details, Rocky opened in a former ice-cream and pizza shop on Colonial Avenue.

Chef Rocky Denson

With gourmet deli meats, wines and other specialties, the store was doing well. "A restaurant was not in the plans," he concedes, then adds, "but I've always loved oysters."

After years of dwindling supplies, nobody was taking oysters seriously anymore, "but I saw that they were taking off again in the same way there were Virginia wines and craft breweries. There were eight regions, and they each had different flavors."

At first his enthusiasm was far from contagious. "I had this beautiful seafood in my cases, but I wasn't selling any."

One chilly November day, Rocky put up a tent outside and started cooking. A man stopped to ask what he was doing, and he told him he was making Brunswick stew. Within an hour and a half, he'd sold out of oysters.

"What are you going to do next?" Blaire asked him.

He was out there with his tent all winter long in the freezing cold, and by the end of the season, he was convinced that adding a restaurant made sense.

"Oysters built this," he says of the R&B Oyster Bar addition to the side of his store. There are tables inside and out. And it was recently ranked the number one restaurant in the Northern Neck by TripAdvisor.

On the wall is a sign that says it all: "To eat an oyster is to kiss the sea on the lips."

He credits Blaire with the motivation to make it happen. "She's the brains. I'm just the good-looking guy. She's very business savvy."

And, though she has a career in education that takes her to Richmond, Blaire has put down roots in Colonial Beach.

Rocky says it's the people you meet every day, the stories you hear and everybody knowing each other that make Colonial Beach special.

Not long ago after what had been a crazy stressful week for the family, neighbors jumped in to help out and lend support. It's exactly that sort of caring, he says, that explains why he can't imagine living anywhere else.

FROM KING COTTON TO PENNY CANDY:
Marguerite Staples

Ask almost anyone in Colonial Beach who's of a certain age, and one of their fondest childhood memories is of buying penny candy at Klotz's GEM 5 & 10 store in what was once the thriving center of the town along Hawthorn Street. Waxy bottles filled with colored sugar water, little foil pie "tins" filled with another sugary concoction and dozens of other brightly colored candies were on display to draw a child's eye. Some also remember the stern "don't touch" rules.

For Marguerite "Margie" Virginia Klotz Staples, though, it was the family business, one she and her husband eventually took over from her parents, until bigger stores came along and their business died off.

For the Klotz family, the connection to this little summer town along the Potomac began in the early 1900s. Her father's family had property at the beach and moved here permanently when he was only five. "He was raised here," she says, though at one point his grandmother sent him and his three brothers off to boarding school in Baltimore.

Until then, though, he went to a one-room school called Hudson House where Mrs. Lena Franklin was the only teacher. She taught seven grades in that single room.

"They had to light a fire when they got there," Margie says. "On occasion they were known to put snow in the stove pipe to cause problems. They were mischievous."

Back then there were only seven or eight students in his class. Though her father only completed eighth grade, she says he was smart. "You could put figures into an adding machine and he could add them faster in his head than the machine could."

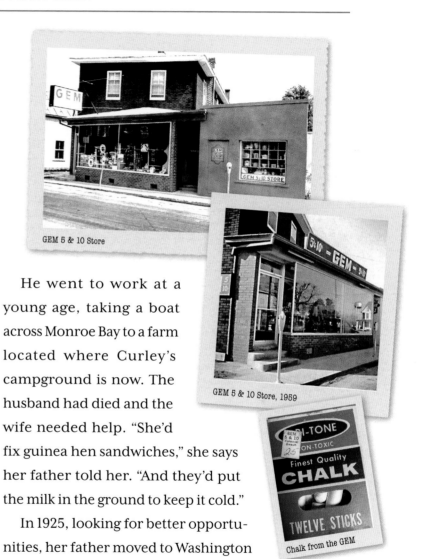

GEM 5 & 10 Store

GEM 5 & 10 Store, 1959

Chalk from the GEM

He went to work at a young age, taking a boat across Monroe Bay to a farm located where Curley's campground is now. The husband had died and the wife needed help. "She'd fix guinea hen sandwiches," she says her father told her. "And they'd put the milk in the ground to keep it cold."

In 1925, looking for better opportunities, her father moved to Washington and went to work for the Capital

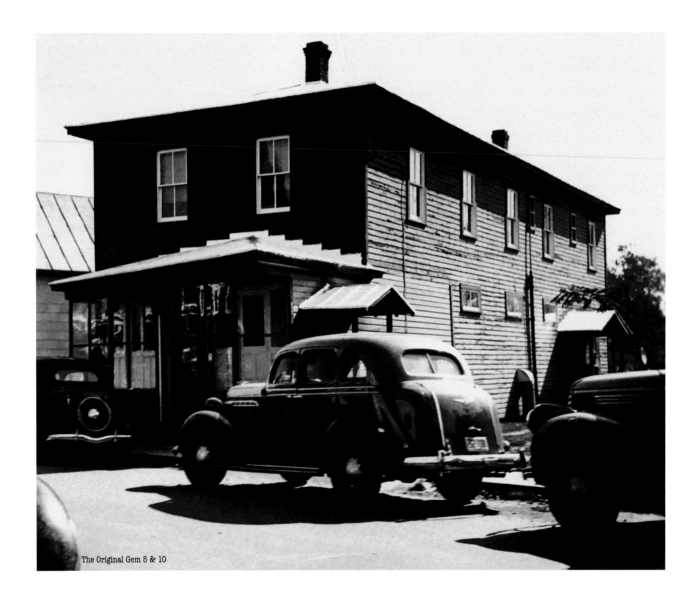

The Original Gem 5 & 10

Transit Company. A few years later, in 1933, he met her mother.

"He'd gone to a party with someone else. He looked across the room, saw her and told a friend, 'That's who I'm going to marry.'"

His idea of a proposal was to announce that they were getting married. He took her to a preacher's house and gave him five dollars to perform the ceremony. Back home, "he gave her a roast and told her to 'cook it while I'm gone [to work].'" Margie laughs. "She turned out to be a good cook."

During this time, her grandmother remained in Colonial Beach running various places in town—the Willow Lunch Restaurant on the boardwalk, the Colonial Beach Hotel dining room, the pub beside the Wolcott Hotel. She helped at the desk at the New Atlanta Hotel, too, and was even one of the town's first telephone operators.

Her step-grandfather ran a poolroom on Irving Avenue. "Dad worked there for a time as a gofer."

It was 1945 by the time her father and mother moved back to town. "He ran the King Cotton Hotel,"

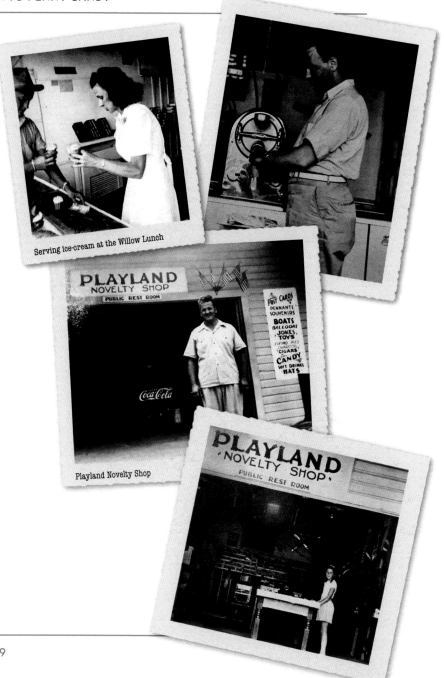

Serving ice-cream at the Willow Lunch

Playland Novelty Shop

Marguerite on horseback in one of the parades

she says. It was located on Washington Avenue, where a small ice-cream vendor—Nancy's—is now located. It was across the street from the Mayfair movie theater.

He opened the Playland novelty shop on the boardwalk and bought a big building on Hawthorn Street. They lived in it above a ten-cent store.

Eventually her father left the King Cotton Hotel and in 1951 with a partner took over the ten-cent store.

Hawthorn Street was the heart of downtown back then. Pearson's Seafood was across the street from their store, as was the post office. That building, once a central meeting place for town residents, now serves as home for the VFW. She remembers Edna Johnson's dress shop, Wright's Family Grocery, Greenlaw's Hardware, Mary's beauty salon and Costenbader's barbershop. The A&P was the town's first major grocery store when it opened just a block from the town pier. The Bank of Westmoreland was across the street. "I worked there when I graduated from high school," she recalls.

"It was a fun time back then," she remembers. "We did all sorts of things. I remember we tried to ride our bicycles to Westmoreland State Park." The park's beach was a favorite of locals back then, but miles away. "We got to Oak Grove [only six miles away] and gave up."

Not everything was wonderful. Though the gambling era in the '50s was good for businesses in town, her father hated it. He recalled parents coming into his Playland novelty shop on the boardwalk trying to hock things for money for gambling. Because children weren't allowed in the casinos, they were often left outside to wander the boardwalk, crying. "He didn't know if they'd been fed," she remembers.

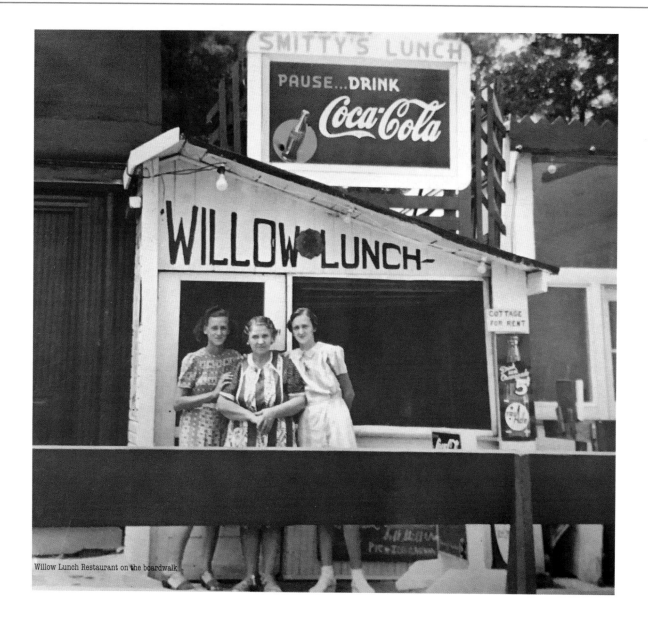

Willow Lunch Restaurant on the boardwalk

Margie married William Frank and had one son before they divorced. "We rode horses in a lot of the parades in town," she says, recalling the annual Potomac River Festival parades that occurred each June. On Friday nights, there was a special and very loud parade of fire trucks and rescue vehicles from all over the region. On Saturdays, there was the main festival parade with floats, marching bands and majorettes and those riders on horseback. On Sundays, the weekend was capped off by a boat parade. Though smaller now, those parades continue today.

Margie is now married to Mitchell Staples. They've been together for forty-nine years. When her father could no longer run the store, she left the bank, and she and Mitchell took over. It was the arrival of a national chain of five-and-dime stores that finally drove them out of business. "They could sell retail for what we had to pay wholesale," she explains.

"Dad lived to be one hundred. We built a home for him next to mine. Every day I'd go over to get him up and about. He'd always ask, 'Where are we going?'" She remembers that every day he wanted to drive around the Point to see what was happening. "It upset Dad when we had to go out of business, but we couldn't make a living selling nothing but newspapers." By then their business had dwindled down to not much more than that.

They tried to reinvent themselves as the Seafair Shop, offering things for summer such as sunglasses, bathing suits and the like, but it didn't work.

Once the store closed for good, Margie worked at the school as a paraprofessional in kindergarten and first-grade classrooms. She also drove a school bus, but eventually gave that up. "I loved that bus," she says nostalgically.

She started playing piano for the church choir at the Colonial Beach Baptist Church on a "temporary" basis, and has been doing it for sixteen years.

She and Mitchell had two children. Their daughter, Kathy, won a contest once that was a promotion for the movie of Tom Clancy's bestseller *The Hunt for Red October*. The prize was a two-man submarine. "She was in college and asked for a cash prize instead." It

was enough to take her off of the financial aid she had for school.

For all of the experiences she's had and the full life she leads, Margie still holds tight to the memories of Klotz's GEM 5 & 10, and the way old-timers in town mention it and her family with such respect.

"We sold everything," she says. "Candy, toys, curtains and window shades. We had all the little stuff. Embroidery thread, cases of buttons."

One of her favorite memories is of a man who came in from a boat looking for a pot to cook soup. "He spotted a chamber pot and took that. I thought that was so funny."

Every now and then she still runs into people who recognize her from the old store and introduce themselves. "They tell me they still miss that store."

She's sure that's something her parents would love to hear.

BUSINESS REALITY: POTOMAC SUNRISE

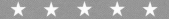

As Margie Staples learned and as Luke Sydnor mentioned, owning a small business in Colonial Beach can be a struggle. In fact, even during the gambling heyday, when summer crowds were especially large, most people who operated businesses along the busy boardwalk had year-round jobs. These days the town's business regulations can be frustrating to navigate. Common sense often doesn't rule.

Still just about every author—or avid reader—dreams of opening a bookstore, and I was certainly no exception. Just like Shanna in the *Chesapeake Shores* series, I decided to follow my dream and give it a try.

And so, in 1996, a friend and I decided to open separate businesses in a house on Washington Avenue. Mary Warring, who loved antiques, ran Potomac Accents in the front of the house. I opened my bookstore, Potomac Sunrise, in the back. Just a few years after opening, I sold my half of the house to Mary and bought the old Baptist parsonage farther up the street and expanded my business to include a wide variety of gifts, along with my beloved books and a coffeepot that was always filled with my favorite coffee. The discussions with the health department over that coffeepot were almost comical.

Originally my intention was to operate only during the spring and summer months, but it turned out, after an experiment, that fall and especially Christmas were the very best seasons of all. Because I only lived in town part of the year, running the business long-distance was especially tricky, even with some very good and loyal employees. When the pipes froze one winter and sent water cascading through the newly renovated house, I was finally forced to reconsider.

Until then, though, I loved having the chance to talk books with readers from all over who came to the store. Talking local news with residents who stopped in to catch up kept me up-to-date on just about everything going on in town. Every week when the shipments of books turned up or the boxes of gifts I'd selected for various sections arrived, it was exactly like Christmas morning. I couldn't imagine anything more fun.

But reality took precedence over the joy of meeting new people, discovering new authors and selling just the right gift or card for someone's birthday or anniversary. After ten wonderful years, I had to close the business in 2006 to focus on the career that paid my bills.

My only regret is that I hadn't waited until I had more time to be on site all the time. Running a small business requires dedication and personal interaction. Those years with Potomac Sunrise gave me a newfound respect for anyone who can survive the challenges and make a success of such a business. One of these days, I'd love to try it again.

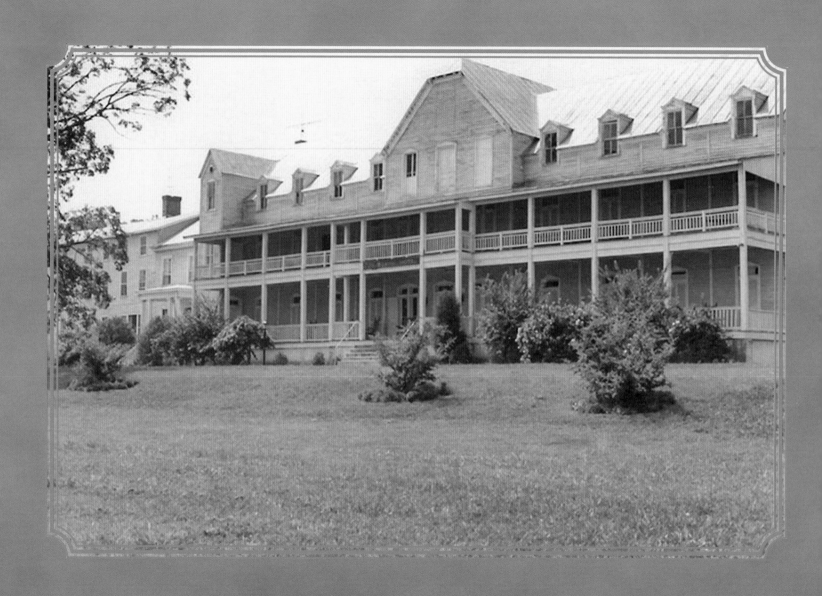

The Town's Welcome Mat:
FROM GRANDEUR TO COZY B AND Bs

When I was spending my childhood summers in Colonial Beach, the sprawling Colonial Beach Hotel sat stop a slight hill in the middle of town facing the Potomac River. At the bottom of its sloping lawn, amusement park rides—a merry-go-round, a train ride, a Ferris wheel and a whip among others—dotted the landscape along the water. Delbert Conner, who'd brought gambling to town, owned the hotel, the rides and even the nearby town swimming pool.

DeAtley Hotel

Westmoreland Motel

The New Atlanta Hotel

Rock's Rooms Hotel

I wanted desperately to grow up and own that hotel, to create a gracious sweeping porch open to the breeze, to have badminton and croquet games on the lawn. Even then, a part of me was living in another era.

Alas, that old hotel, which was purported to have a resident ghost and was the onetime home of General Henry "Light-Horse Harry" Lee, was eventually declared to be too run-down to save and was demolished in 1984, long before I could get my hands on it and create the hotel of my childhood dreams.

Perhaps that thwarted desire led to my fascination with charming and welcoming small hotels such as The Inn at Eagle Point in the *Chesapeake Shores* series. They may eventually knock down some of these gracious old hotels in real life, but I can keep them going in my books.

In the early days in Colonial Beach, visitors had a variety of options. There were boardinghouses all over town, homes where dinner bells rang to call guests in for an evening meal.

Small hotels were situated on the boardwalk and beyond—Rock's, DeAtley's, the Wolcott, Linwood House, the King Cotton, the New Atlanta Hotel, the Crown

Alexander Graham Bell House

family vacations, to gamble or to listen to music from the likes of Guy Lombardo, Kate Smith and Patsy Cline.

When the gambling was outlawed in 1959, many of these smaller boardinghouses and gracious, if small hotels that dotted the Colonial Beach landscape died with it. Motels were shuttered or their rooms rented to transients or to churches offering a hand to someone down on their luck. In some cases paint peeled and lawns were overrun with weeds.

In their place came a handful of rental cottages and bed-and-breakfasts. The most famous of these is the Bell House, once the summer home of Alexander Graham Bell. A pale yellow Victorian with a wide porch and a sweeping view of the Potomac River, it had a gracious proprietor in Anne Bolin, who was proud of its history under the ownership of the man who invented the telephone and even allowed my publicity photo to be shot on that front porch. The Bell House was filled to capacity on many summer weekends. Its fate is in doubt now due to Anne's passing on February 17, 2017.

And then there is Doc's Motor Court. Doc's is in a class by itself. Opened in 1948, it sat just across the

Castle. Many had porches with rocking chairs and a view of the water, or was certainly within walking distance of the Potomac. Some had their own restaurants.

There was a scattering of small, local motels—the Wakefield, the Westmoreland and others—long before chains became the norm across the country. And during the gambling heyday, when casinos were built on piers over the river, every motel, hotel and boardinghouse room was filled with those who came for

street from the main beach and the town pier. Guests pulled their cars into the tiny courtyard to park directly in front of their rooms. They were welcomed at first by Doc Caruthers, who was never a doctor at all, but the son of one, and after a time by Doc's wife, Ellie, a former nurse who told her husband she had no idea how to run a hotel when he handed her the keys.

"You'll learn just like I did," he responded and went off to the "real" job she'd insisted he get before she'd marry him.

So Ellie learned and the guests came, many of them over and over again through the years. Her notes reminded her of which rooms they preferred, which festival or holiday drew them here, and anything else that she needed to know to make them welcome.

But though Doc is gone now and Ellie closed the motor court a few years ago, Ellie remembers the repeat customers even without those detailed notes. And the guests still come back to reminisce, begging to stay one last time, though the doors have been locked tight. Often she lets them, as long as they bring their own sheets and towels and leave their favorite rooms as clean as they found them.

That's just who Ellie is, as welcoming as a favorite aunt, a storyteller with a long memory and a quick wit.

Not too long ago my cousin, Michael Fitts, an artist who lives in Charlottesville, was here visiting. I told him and his brothers and their wives about Ellie and about Doc's. Mike's eyes lit, his artistic sensibility awakened. He immediately turned to his wife. "That's the place we saw. I told you I wanted to stay there."

When I mentioned that to Ellie, she immediately said, "Bring him by."

And I will, because no one should miss the chance to meet Ellie Caruthers. And for those of you who might never have that chance, here's her story.

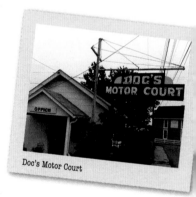

Doc's Motor Court

She remembers well what it used to be like when Colonial Beach was crowded with tourists who, it seems, were always welcomed like family.

MAKE NO MISTAKE, IT'S A MOTOR COURT, NOT A MOTEL:
Ellie Caruthers

Eleanor "Ellie" Mae Crary Caruthers is quick to distinguish Doc's Motor Court from the motels that have proliferated all over the United States for the past half century or more. As the caretaker of this quaint Colonial Beach piece of history and all its stories, she wants to make sure that visitors understand the difference, not that it's hard to spot.

Two short rows of single-story, white structures face each other at a slight angle across a courtyard reserved for guests to park their cars right in front of their rooms.

Doc's parents, Dr. and Mrs. Veola Caruthers

On many a summer day guests could be found lined up in old-fashioned, brightly colored metal chairs on the narrow stoops outside their doors or at the edge of the property with its stunning view of this miles-wide stretch of the Potomac River just before it flows into the Chesapeake Bay. A clothesline is strung between posts for hanging damp beach towels and bathing suits, adding to the oddly homey atmosphere.

Families gathered at the end of the day to talk, wet bathing suits were hung out to dry and, on the Fourth of July, way back in the day before the town set off fireworks on the nearby Town Pier, guests would get a permit from the town and shoot off their own. Once one of the returning families had done it, others insisted on doing it too, creating increasingly lavish displays on the annual holiday. Guests were even front-row witnesses on the night the town's fireworks started a fire and a town fire truck drove onto the pier to put out the blaze and crashed right through into the river.

Ellie remembers it all, every detail about those first fireworks, every request made by the regulars, which rooms they liked and even stories they told. She talks about the Potomac River Festival parades passing by and more recently the congestion caused by a change in the traffic pattern. She finds it all endlessly fascinating.

But unlike her husband, who saw the need for such a place in this small but busy little resort town nestled on the shores of the Potomac halfway between Washington, DC, and Richmond, Ellie had never intended to live such a life in such a place.

Born in 1927 at Vanderbilt Hospital in Asheville, North Carolina, the daughter of a brick mason, she discovered at an early age just how tough life could be. In 1934 the banks went broke and her father lost everything—his business, their home, their belongings. With

c Caruthers on left

help from Franklin Delano Roosevelt's WPA program, the family moved to the nation's capital where her father found work.

"They called them the Greatest Generation," she says, her tone wry. "It wasn't because they were something special. It was because they were tough. They managed to live through those hard times."

For a time her father did whatever he could to support his family, digging ditches before finding work once again as a brick mason and then eventually starting his own business. He obtained government contracts, worked on monuments and did some of the brick work at Georgetown University, she recalls with pride.

Ellie worked hard, too, commuting to a distant high school to complete her education, then going to nursing school and getting a job at Gallinger Hospital, which later became DC General, and after that a residence for the homeless. The first time she had a vacation coming to her, she talked about it with her dad. They wanted to celebrate by doing something different, going someplace they'd never been before after years of visiting nearby Maryland and Delaware beaches. Her dad had been working at the Dahlgren Naval Surface Warfare Center just outside of Colonial Beach, so they chose Colonial Beach for their holiday.

"We rented a cottage up on Twelfth Street from the undertaker," Ellie recalls. Her dad rented bicycles for her and her sister so they could ride along the waterfront into town to the main beach.

It was there that she met Doc Caruthers in 1949. He was the son of the local doctor and had already opened the motor court, which operated from late spring through early fall, about four months of the year.

What amounted to a long-distance courtship wasn't easy back then. Doc would

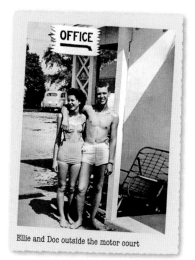

Ellie and Doc outside the motor court

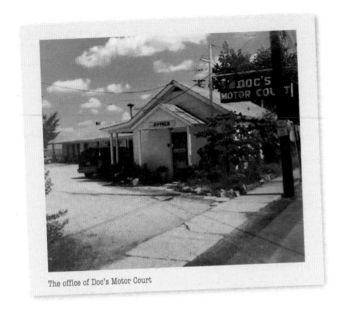

The office of Doc's Motor Court

Through an uncle who worked at the naval base and a navy veteran himself, Doc was about to line up a job there as a plumber. "He was a real good plumber," Ellie recalls. "And he dressed nice."

A chance encounter on the base moved him in an entirely different direction, toward those newfangled things called computers. The big ones new to the base. Doc had no idea what a computer was.

"What's that?" he reportedly asked the friend, John Blue.

Blue described it as a fancy typewriter. Doc apparently nodded and told him, "Oh, I like typewriters and adding machines." To Doc, Ellie says, "It was all fun and games. He loved gadgets."

In fact, his love of gadgets could be a bone of contention between them from time to time. "He'd drive me insane," Ellie says with the affectionate tolerance of a beleaguered wife who knew her husband's faults all too well. For ten years, they lived in a couple of rooms behind the office at the motor court. They then moved into the Sears, Roebuck house that Doc's mother and father had built in 1937.

only rarely ask to use his father's phone to call. "We wrote letters. As you can imagine, I wrote epistles," she says, a laughing reference to her habit of spinning a story infused with details. "Doc would write back, 'I might be able to get up there Tuesday night.'"

When Doc first proposed, Ellie was having none of it. She wasn't about to marry someone who only worked four months out of the year. "I had a real job. I told him he needed to find one, too."

During those years, Doc was always looking to buy this gadget or that, to try building some boat he'd found the plans for. Ellie was the voice of reason, warning when they couldn't afford something or had nowhere to put it, but more often than not, she got caught up in Doc's latest enthusiasm.

"Doc was a boat-building nut," she says affectionately. "The first ones sank."

She recalls vividly his discovery of the recipe for making a "flotation kit," and it came with some boat kit that Doc wanted to assemble. They filled boxes and coffee cans with the mixture, according to the directions. "They started swelling up till they looked like loaves of bread." Some of those ended up with a local waterman, Henry Parker, to float his crab pots. Some of it was used to build a kayak that couldn't be sunk. Their two adopted children—Sarah and Mark—along with their friends, did their best to try, but they couldn't sink that kayak.

Doc even got the plans for a Mediterranean caïque from *Popular Mechanics* magazine, just because the look of it fascinated him. He built a twenty-three-foot cabin cruiser from a kit. It took him years to build it and required fiberglass to make it seaworthy. Once it was done, he took it up to Washington and sold it. The smell of that fiberglass caulking made them both "drunk as a skunk," Ellie recalls with a chuckle.

While Doc learned everything he could about computers at his job on the base and, then, at home, Ellie ran the motor court. Initially she thought she'd run it for those four months of the year as Doc had, then work in the nursing profession in nearby Fredericksburg the rest of the year. The administrators at the hos-

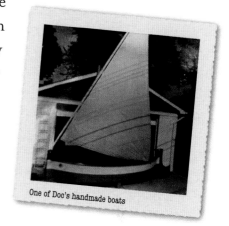

One of Doc's handmade boats

pital there weren't enthused about having a nurse who was taking such a long vacation every year. "They laughed me right out the door."

When a new doctor arrived at the beach, though, he was happy to have Ellie working for him. And even after he retired, she kept his records in case the patients ever

Doc with daughter Sarah

Doc on left and Ellie on right

needed them. When they'd gone unclaimed for years, she asked what she ought to do with them. Told they needed to be destroyed, she had a fire and burned them to protect the patients' privacy. And, as a legacy from her father-in-law, she still has some of the big old jars of medicine from which he'd dispense prescriptions to his patients.

While nursing was the profession she'd trained for, Ellie was a natural at running the motor court. Even on the day of the interview, with Doc's closed now for a couple of years, she was getting calls from old customers. Some were just checking on her. One, Chet, checks in regularly. He was eight years old the first time he came with his parents. "He's in his seventies now," Ellie says.

Others want to reminisce about a place that had been so important to them or their family. One who called that day told her he was over by the motor court and asked if she had a little time. "I'd like to talk about my dad."

Of course, Ellie remembered him and hurried right over. "He was from West Virginia," she recalled. "And he raised minks. I thought that was so interesting." Her eyes sparkled at the memory.

On one of his visits the father had noticed that the small perch—a sweet, if bone-filled, fish caught in the Potomac—were being tossed aside at the end of the day. "After that, he sent over a truck and took those fish home to feed his minks."

Another vivid memory of another guest comes to mind. The man checked in, but when checkout time came, he hadn't left and wasn't answering his door. Ellie used her key, entered his room and found him unconscious. She recognized his symptoms as an overdose, called for help and got him to a hospital in time to save his life.

Another guest told her he'd like to be buried under the ginko tree in the motor court's courtyard.

Then there was Julius, a baker from Washington, who came every year and often brought baked goods with him. He and his family loved their annual visits, and Ellie automatically reserved their same room for

them at the beginning of the summer season, whether they'd called yet or not. Then one year his wife called to cancel. She told Ellie her husband had been very sick.

The next year Ellie didn't record their reservation in advance. At the last minute the wife called to see if there was any way to get their usual room on such short notice. Ellie went to the person already staying in that room, explained the situation and, just as most people jump to do Ellie's bidding, the guest gave up the room.

The family arrived and the husband was full of stories about all he'd noticed coming into town, the memories he had of all the vacations spent here.

Ellie left their room and was halfway across the courtyard when the son came to get her. "You need to call for help. Dad's died."

Julius had accomplished what he'd wanted. He'd come to the place he considered home to die.

Ellie has countless stories like that, of people who considered Doc's home and her a beloved part of their family. It's not at all hard to understand, but it is rare, and she knows it. Part of it may have to do with the lure of this small seaside town, but a lot has to do with Ellie herself.

"Nursing made her a good listener," one friend commented.

It's more than that, though. It's the deep affection she clearly holds for Doc, for Colonial Beach, for the life she's led and for the people who've enriched her days with their own stories.

"I think that's so interesting," she says time and again of what she's learned from her guests and from living.

There's a lesson in that, perhaps. That as long as you're living and listening and learning, life is full. Ellie, ninety now and still active even without the demands of the motor court, would most certainly declare that hers is.

Ellie at her 90th birthday party

By the Sea, By the Sea...

Whether it's because of my birth sign—Cancer—or for some other reason, I am happiest when I'm by the water. Big bodies of water. It doesn't matter if it's the wide sweep of the Potomac River in Colonial Beach just above where it empties into the Chesapeake Bay or the vastness of the ocean; the sea soothes my soul.

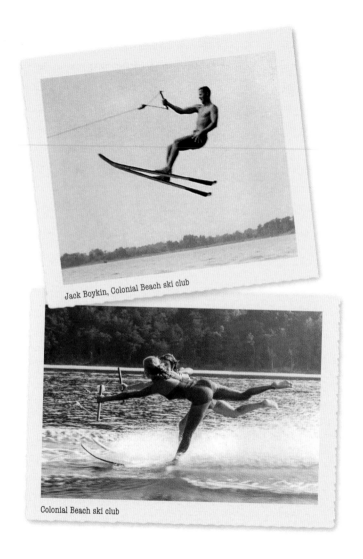

Jack Boykin, Colonial Beach ski club

Colonial Beach ski club

I lived for many years in Columbus, Ohio, and grumbled mightily about the lack of water. Rivers were proudly pointed out to me—the Scioto, the Olentangy. I always shook my head. "Nope, those are creeks."

And yet despite that fondness for walking along the shore, for sitting on my porch with its view of the river or on my balcony in Florida with its view of the Atlantic, I'm a little less enthused about being on or especially *in* the water.

Despite having a mom who was a competitive swimmer back in the day, despite plenty of swimming lessons over the years, I am a terrible, terrible swimmer. I do all the right strokes—back stroke, side stroke, breast stroke. I stay afloat...for a time. But I forget to breathe. That is not a good trait when in a wide expanse of deep water.

My parents were well aware of my lack of skill. As a teen, I was forbidden from joining my friends at the beach when they built a questionably watertight rowboat or engaged in impromptu waterskiing competitions on the river. For once I didn't argue.

Therefore a few years back when I was asked to be the grand marshal of the Potomac River Festival boat parade,

I asked with a great deal of hope, "Can I do it from land?" Sadly, they assured me that wasn't an option.

So, with the help and encouragement of several courtly men, I boarded a lovely boat, planted myself very securely in a seat in the stern of the boat and sat there for a couple of hours, waving dutifully to those on shore and aboard the many decorated boats, and watching nervously for even a hint of rough seas. As honored as I was, as kind as everyone was, it was the longest couple of hours of my life.

In Colonial Beach, being on or in the water is a way of life for many residents. Though it's a slowly dying existence, there are still watermen in town who make their living crabbing or fishing. There are very few oystermen left because of the dwindling supplies in the river and the nearby Chesapeake. Curley's Oyster Packing Plant, which once employed several dozen shuckers and shipped out truckloads of oysters in fancy tins that are now highly collectible, has shuttered its doors. The *Big Dipper*, once a charter fishing boat and tourist boat, is now in private hands. And while Clarence Stanford's Marine Railway is now

called the Boathouse Marina and still offers docking facilities and boat repair, it's no longer in the boat-building business.

And, yet, this town still has its share of pleasure boats and marinas, which contribute greatly to the local economy. According to an estimate by Bill Bowman, who owns the Boathouse Marina, the various marinas in town—including the Colonial Beach Yacht Center and the Curleys' Monroe Bay Marina—provide some six hundred slips, about two-thirds of which are leased out on an ongoing basis. The rest are leased to summer boaters who find

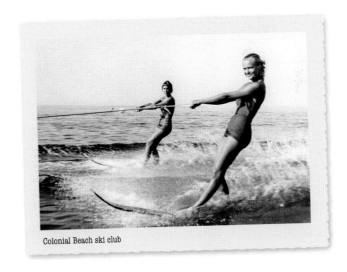

Colonial Beach ski club

Colonial Beach an accessible and desirable port between Washington and the Chesapeake Bay.

He estimates that those who own these docking facilities have in the neighborhood of ten million dollars in capital investments in their operations. Add in what boaters spend on service, equipment, groceries and so on while visiting Colonial Beach or staying on their boats, he calculates that's another two million dollars contributed annually to the local economy.

"Colonial Beach was once a place for old boats to go to die," he says. Now the boats coming to the beach can range anywhere from one hundred thousand dollars on the low end to one that's worth three-quarters of a million dollars. He, among other marina owners, including Kyle Shick of the Colonial Beach Yacht Center, fought a boat tax that the town once levied, arguing that boaters already contribute greatly to the economy. The added personal property tax for docking in local waters on a permanent basis would only send them fleeing to a more welcoming, less costly port. Many of the marinas, including Bill's, suffered severe damage in a freak storm in spring 2017, but quickly worked to repair slips and buildings to be ready for the summer season.

But while pleasure boating has taken its place at the forefront of businesses making a living from the area's waters, the town still has families who recall a different time, when they earned their livelihoods on the water in a variety of unusual ways, from building sought-after boats to running fishing charters, from distributing seafood throughout the region to catching muskrats. A few still do.

Here are just a few of the stories of those unique, colorful individuals. It's a history as important to the town as the nearby birthplaces of George Washington, James Monroe and Robert E. Lee and just as memorable.

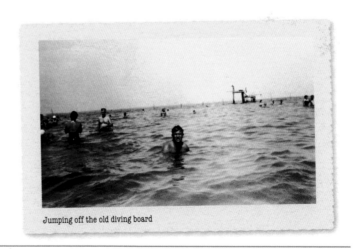
Jumping off the old diving board

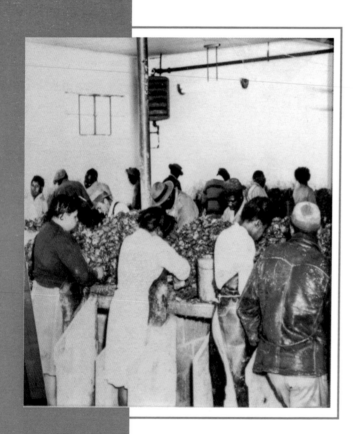

A LIFE BUILT AROUND OYSTERS:
The Curleys

Few families in Colonial Beach are more identified with making a living from the nearby waters of the Potomac River and Chesapeake Bay than the Curleys.

Landon Curley, who founded the Curley Packing Company in 1932, "loved oysters," says his son Rusty. "That was his thing. He'd see oyster boats lined up in the creek [Monroe Bay] and nothing looked any better to him."

At one time the boats lined up in droves, side by side, so close together you could walk across the water by hopping

nroe Bay Marina

from one deck to the next, Rusty and others recall about the heyday of oystering in the 1950s.

A flag flying from a pole outside the packing plant suggested to the working watermen as they entered Monroe Bay the kind of prices they could get for their haul by bringing it to Curley's, rather than other packers in town or elsewhere. And there, not only would they get top dollar, they'd find a welcoming place to spend an evening with good food, lively company and some competitive pool games.

"You couldn't find a more colorful group of people," Rusty recalls. "They might not have had the purest language, but they were good people. They had a respect for women."

And the watermen came back season after season from Tangier Island and around the region because Landon Curley treated them right. Rusty still talks longingly of one who'd always bring some fig preserves made by his wife.

Sometimes the men would go home, leaving their boats docked at Curley's as they visited family. They'd leave one man behind to make sure any water that seeped into the boats was promptly pumped out. "He used to say the sweetest sound he ever heard was of that pump sucking air," Rusty recalls of the hard, laborious task.

Possibly because they were still young at the time, the siblings—Rusty and his older sisters, Linda and

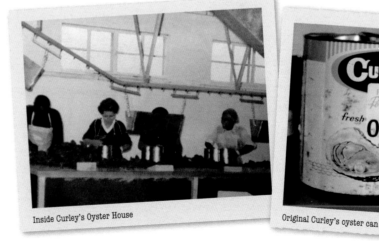

Inside Curley's Oyster House

Original Curley's oyster can

Candy—say their father never discussed the Oyster Wars that were raging for a time on the waters of the Potomac during the 1950s. He never mentioned if watermen from Virginia were illegally dredging from oyster beds at the bottom of the Potomac River in defiance of the law. Nor did he discuss the lax Virginia patrols or, by contrast, the fiercely protective Maryland patrolmen, who were often taunted by the determined oystermen with their faster boats, some of which were owned by Curley himself.

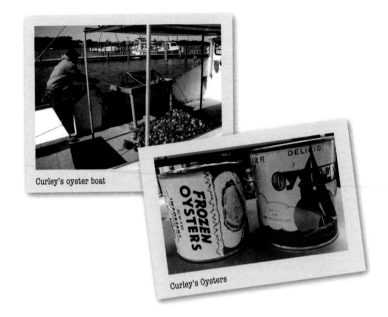

Curley's oyster boat

Curley's Oysters

Yet the legend of Maryland patrol boats firing on watermen, sending a hail of bullets into boats and on to shore during that era is well-known. Almost anyone living near the water during that period has a story to share of hearing the middle-of-the-night shots, witnessing the gunfire or finding bullet holes in buildings just onshore from where watermen outmaneuvered the patrols to seek safety in protected Monroe Bay, which was in less dangerous Virginia territory.

In one account, reported in *The Oyster Wars of Chesapeake Bay* by John R. Wennersten, at least four hundred people had gathered onshore one wintry night in 1957 to watch as two patrol boats and a seaplane tore after waterman Harvey King in a chase worthy of a Hollywood movie. Bullets slammed into the Wolcott Tavern on the Colonial Beach boardwalk, but luckily no bystanders were hit and King made it to shore unscathed, though his boat was hit. He was arrested, but the squabbling that ensued between Maryland and Virginia was as fiery as the gun battle. Astonishing many, when King was tried eventually in Maryland, he was acquitted.

Landon Curley might have known about the illegal dredging, he might even have owned a few boats that got tangled up in the fighting, but he didn't talk about it with his children.

The history of that time is well documented in Wennersten's book, which also describes the gunfight that ended it all with the shooting death of Colonial Beach waterman Berkeley Muse, who was aboard Harvey King's boat. King, who'd ignored the advice of many after his earlier brush with Maryland patrol boats and the law, was also injured in the fight. He got the boat to shore, but Muse was already dead.

Bozo Atwell, 1962

The one story of that era that Rusty does recall hearing from his father was of the arrest of Bozo Atwell, who worked in various jobs around the marina, and got caught up in a scuffle over oyster dredging. He was aboard one of Landon Curley's boats at the time and allegedly led patrolmen on a merry chase, then threatened them with a rifle. After he was arrested, officials demanded that boat as payment to get Atwell out of jail. Curley had already sold the boat, but he bought it back and made the exchange.

"I think that says a lot about the kind of man my dad was. He was loyal to his friends," Rusty says.

Growing up with such an example to follow and in such an environment was incredibly special, Rusty says. His sisters, Linda Gouldman and Candy Coates, concur, though to hear the women tell it, Rusty got a bit of preferential treatment, being not only the baby of the family, but the only son.

"We worked the gas pump in the marina, we learned to shuck oysters just to help Daddy," Linda recalls. "We didn't get paid. Rusty did."

After working together for fifty years, the teasing among the three siblings, as they recall growing up around oystermen and the packing plant, speaks to their devotion to the family and their enjoyment of that period of the Curley Packing Plant.

Not a one of them had any desire to leave the familiar lifestyle.

Candy worked in Richmond for three years, and Linda worked at Dahlgren for eight years while her husband, Russell Gouldman, worked for the family business. Rusty, the youngest, worked at the packing plant when he wasn't in school and then full-time after graduating.

All three graduated from Colonial Beach High School, as did their children.

Both Rusty and his brother-in-law, Russell, worked for the family business for fifty years, while Candy and Linda worked there for forty years. Linda's son, Brian Gouldman, became the newest family member to join the business, working there in summers during high school and now full-time since 2010.

"Our dad loved his family and the business, and he always wanted Curley Packing Company to remain family operated," Linda says.

Vacations were rare, but one time Rusty went to Florida for a week, leaving Russell in charge of the oyster plant. But Russell fell ill with a nasty flu, and the

Docked boats at Monroe Bay Marina

Docked boats at Monroe Bay Marina

Monroe Bay Campgrounds

L. L. Curley Sr. Memorial

sisters pitched in doing tasks they admit tested their skills just so their brother wouldn't have to turn right around and come back home. "That's what you do in a family business," Linda adds.

If they each have a great understanding of what it takes to work together, they also have a deep appreciation for life in a small town. "It's a comfort knowing so many people," Linda says of living in Colonial Beach her whole life.

"If you're walking down the street, you can barely get a block or two before someone will come along and offer you a ride," Rusty adds.

People would also tell on them if they were caught misbehaving, Linda says, then adds with a pointed look toward her brother, "But Candy and I were never in trouble."

"I tried to give him some of my wisdom," Candy said, also glancing in Rusty's direction.

Rusty takes the teasing in stride, then can't help mentioning that his mother, at least, was strict with him. "I was in my thirties, divorced and living across the street, and she'd wait up for me, then call to tell me I'd been out too late. 'Your father's trying to sleep and he can't,' she'd complain. Well, if Daddy couldn't sleep, it was because she was poking him to tell him I wasn't home yet," he recalls, laughing.

When they speak of their father, it's always with deep pride and respect. There's a small stone memorial to L. L. Curley with an American flag flying in the courtyard of what used to be the bustling packing plant. Where oyster boats once lined up, there are now marina boat slips. Times change.

At one time that packing plant had tractor trailers waiting to haul away a cargo of oysters graded as standard, select and count. They were shipped out in specially designed tins labeled with the Pearl of Perfection logo of the Curley Packing Plant. Nowadays, with the plant closed since the 2002-2003 oyster season, those old tins, even those not in the best condition, thanks to time and the rust from salty water, are considered collectibles.

"I paid $350 for the last one I bought," Linda says.

"I think I paid $250," Rusty adds. But recently he heard that while a gallon of oysters could be had for

Mural outside Curley's Oyster House

Curley's Oyster House

twenty-five dollars, one of those old gallon tins sold for a whopping $1,800.

Though the oyster supply had been diminishing, they kept the packing plant going for as long as they could in their father's memory. For the last four or five years they remained in business, they had trouble even getting enough oysters to fill their orders during the prime oyster-selling season between Thanksgiving and Christmas. In addition, they couldn't find shuckers. They had one employee for a time who simply wasn't as skilled as the rest and made a mess of the shucking process, dealing with the oysters as clams. They couldn't bring themselves to fire this worker, though..

Regulations were changing, too. Rules pertaining to the way oysters had to be handled, the temperature requirements in the plant—the shuckers wanted the room to be seventy-two degrees, the health department required the oysters to be kept at thirty-five degrees—and the destruction of so many oyster beds after Hurricane Isabel. All of it convinced them it was time to close the plant. It was a reluctant family decision.

The Curley siblings continue to operate the Monroe Bay Marina on the old packing plant property, as well as the Monroe Bay Campground and the Monroe Bay Mobile Home Park just across the creek on land their father had once intended to build on. Instead, people came along and started putting tents up from time to time. It evolved into a thriving campground business that's open from April to November.

It, too, was damaged in the early spring storm in 2017, but the family and friends dove right in to get it cleaned up.

Though the campground has a long history in Colonial Beach, if you mention the Curleys, old-timers will always think about oysters. And, according to his children, that's just the way Landon Curley would want it.

Linda Gouldman, Candy Coates and Rusty Curley (left to right)

SAND IN THEIR SHOES:
The Mears Family

They lovingly refer to Colonial Beach as Mayberry on the Potomac and declare that it's a town that finds its way into your heart and stays there.

Diane Anderson and Zedda Viets are two of five siblings who were raised in Colonial Beach and never left. Well, almost never. Diane and her husband, Andy Anderson, moved to Florida during one brief period when he'd lost his job as police chief thanks to a change in the town's political leadership team. He became a detective in Dania Beach,

Florida, Diane recalls. "I hated every day of it."

At the first opportunity, the Andersons, along with a couple of other officers and their families, packed up U-Hauls and headed in a caravan right back to Colonial Beach. In all, Andy was a police chief in town for fourteen years, and Diane finally got over being embarrassed by having people stop them on the street to reminisce about the times they'd been arrested or jailed by Andy.

For Zedda, who worked in banking for her entire career in the town where she'd grown up, there are much fonder memories of the opportunities she had to help people with their financial needs.

But all of that came later. They were born to a hardworking waterman, Pud Mears, and his even

The *Lord Baltimore*

The *Miss Potomac*

harder-working wife, Mildred "Millie" Mears. There were two other sisters and a brother. Zedda was the baby, but that didn't save her from doing her fair share of work.

"Our grandfather ran a schooner up and down the [Chesapeake] bay," Diane recalls. "Our father was born in Baltimore. He had five boats, including the *Miss Potomac*, which ran sightseeing rides and charter fishing excursions from fisherman's pier by the town's boardwalk." He had help who operated his other boats for a share of the proceeds.

He did very well, they report proudly, especially for a man with a very limited education. "He only went to second grade because he was needed to help out at home. He had to go out and sell eggs."

That work ethic, instilled when he was so young, was passed along to his children.

"All of us kids worked on the boats," Zedda recalls.

After every fishing trip, "the older siblings would stay aboard and mop the decks or set up chairs," Diane remembers. "The first mate would earn twenty dollars a week, the second mate was paid ten dollars or fifteen

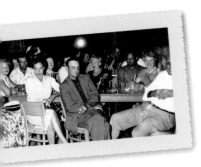

dollars. Zedda, as the baby, got two dollars. We saved everything we got in mayonnaise jars. For an allowance we'd get twenty-five cents. We'd go to Caruthers and Coakley [drugstore] where we could get a soda in a glass for five cents. If we got it in a paper cup it was six cents."

They both recall how safe the town was back then. "I don't think we even had a lock on the house," she says.

"I'd walk around the Point carrying my doll," Zedda remembers. "At seven, eight or nine, we'd go trick-or-treating and feel perfectly safe."

One thing Pud insisted on was having his boats spotless. That meant scrubbing them down between trips out on the river, whether for fishing or sightseeing on a sixty-minute ride toward George Washington's birthplace at Wakefield or around the Point into Monroe Bay.

"We'd take our schoolbooks on the boat," Diane recalls. Their mom would bring lunch down to the pier between trips.

The fishing excursions would last until the weather turned cold, and then their dad would go to work for the Norman Oil Company and the kids would ride along hauling hoses to fill the fuel tanks at homes around town. "He always took butterscotch candies for any kids we ran into and dog biscuits for the dogs," Zedda says.

Their chores didn't end with helping their dad, either.

"Mama loved flowers," Zedda remembers. They'd get paid two dollars for pulling weeds all along the fence. "Diane was more careful than I was. I'd get stuck out in the field because I'd cut down every flower Mama had."

They both recall how the family would make ends meet by sharing their catch of perch with a neighbor, Junior Parker, who'd in turn share the occasional bushel of crabs.

"Mama was a good cook," Zedda says. And their house was always as spotless as the boats. "The floors were waxed with bowling alley wax."

While they grew up during the era of casinos and gambling, "We were raised very strictly," Diane says. "It wasn't an environment we were allowed to be in." The

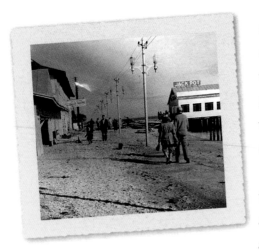

same was true if the day's charter fishing excursion was likely to be a rowdy group of men. The girls were all assigned to work on another boat that day.

But while their parents tried to shelter them from any rough-and-tumble activities, it didn't mean they objected to the presence of the casinos during those years. Their mother, in fact, operated Millie's Snowballs on the boardwalk within yards of the casinos. And every year their mother and father would go to Reno to see the Guy Lombardo band with Walter and Alberta Parkinson.

"Dad would have a highball," Diane says. "It was the only time he drank. They called it their night of sin and said they had the rest of the year to repent."

They remember the objections that the Baptist preacher at the time had to the gambling in town. "He preached against Reno, so we were Methodists."

Both women are still active in that church. "There are a lot of things to be involved with in the community," Zedda says.

"We have a spaghetti dinner at the church that benefits different things. Andy does the cooking," Diane says. There are ten or so regulars who run the kitchen for those events like a well-oiled machine. "It's good fellowship. They solve the problems of the world in that kitchen."

Andy might head up the cooking crew on the night of the event, but Diane does her share. With a double oven at home, she baked twenty-four cakes for a dinner last year benefiting the Colonial Beach Volunteer Rescue Squad.

"The same customers come every time." People run into neighbors and share the meal at a table with folks they might otherwise rarely see.

Diane worked for the government, specializing in computers at the Naval Space Surveillance System at Dahlgren. Zedda worked in banking. She had to wait for the much-coveted position until someone left the Bank of Westmoreland, which later became First

Shores of Chesapeake Bay

Virginia and most recently BB&T. Now she manages several regional branches of BB&T.

They both talk about the small-town feeling they love, about the neighbors caring for each other and watching out for each other's kids.

During Andy's tenure with the police force, he got to know a couple of generations of kids, especially as a truancy officer. Often he'd pick up a kid for misbehaving and take him or her home to let the parents deal with any discipline.

And in the way of small towns everywhere, stories of misdeeds were quickly passed around. Diane recalls hearing from Bill Cooper, who owned the closest thing the town had to a department store back in the day. He called and taunted her by suggesting she ask her husband what he'd been up to that day.

It turned out Andy had arrested a woman who'd taken off all her clothes and ditched them somewhere. He had to escort the naked woman up the boardwalk to his police car, an act that was noted and spread through town at a rapid-fire pace.

It's Diane's words that sum up how she and her siblings feel about Colonial Beach, where they grew up with hard work that did nothing to take away from childhood innocence and joy.

"It's not just a place to live," she says. "It's a place in your heart."

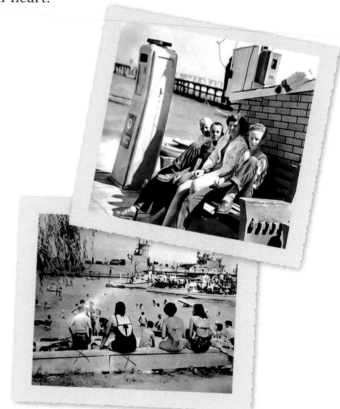

A FISH TALE:

Alberta Parkinson

Like so many people who came to Colonial Beach in their youth and wound up staying a lifetime, it was all about a man for Alberta Parkinson.

Born on November 26, 1926 in Washington, DC, Alberta first came to town to stay with her aunt and uncle who rented a cottage at the small beach town on the Potomac. On some occasions her father rented a cottage for the family from a professor at George Washington University, so throughout her childhood Alberta was a summer regular.

She remembers the boat rides and fishing trips that left from the town fishing pier every thirty minutes or so all day long, the announcements made on the loudspeaker that echoed up and down the beach and boardwalk. "It made things seem so alive," she recalls.

There was plenty to do along the boardwalk back then. "There were two or three bingo places, a shooting gallery, snowball stands. They even had moonlight boat rides.

"I went on some of the boat rides," she says, and remembers sitting in the stern of the boat. What she doesn't recall is the exact moment when Walter Parkinson caught her eye...or she caught his.

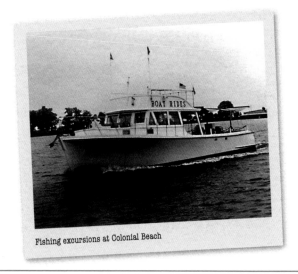
Fishing excursions at Colonial Beach

Walter, along with his father, took out fishing charters and scenic boat rides. They'd take tourists on rides over to Cobb Island and back or to other destinations on the river, pointing out the local sights. It was the Parkinson family business.

"His father was from the Eastern Shore," Alberta recalls. As had so many others from that area who wound up in Colonial Beach, Walter's father had met a local girl and settled in this small town that depended for much of its livelihood on the water.

At some point the tall, dark-haired girl who spent her time on a towel at the nearby beach captured Walter's attention. He started coming up to Washington to court the young woman, who by then was working as a doctor's assistant. He even took dance lessons at an Arthur Murray studio to impress her.

"We'd go to a dance hall on H Street, Northeast. We'd have cocktails and dinner, then go in the back for dancing," she remembers, her eyes lighting up. "Sometimes we'd go downtown to eat, or go to the theater at the Capital Stage to see shows."

Haines Point, Washington, DC

She remembers distinctly that on the night he proposed, they'd gone to Haines Point, with its romantic view of Washington and a place where young people congregated in their cars at night. Because she'd been summering in Colonial Beach most of her life, the thought of giving up the faster-paced lifestyle of Washington didn't bother her a bit. She said yes.

But even after that proposal, it was a year or more before they got married in 1954, because Walter wanted to finish the house he was having built for her prior to the wedding. Local builder Jim Jett was constructing the ranch-style house on a prime piece of waterfront property facing Monroe Bay. From their living room window they were able to see the Stanford Marine Railway, where Clarence Stanford built two of Walter's most famous wooden boats—the *Big Dipper* and its sister ship, the *Midnight Sun*. "Clarence built wonderful boats," she says.

Alberta and Walter married in an 8:00 a.m. ceremony at Our Savior Church, just blocks from the family home in Washington. After a reception at the house, they drove south to start their lives in Colonial Beach.

She recalls that he carried her across the threshold into their new home, which was only partially furnished, then told her, "Don't make any plans for summer. We'll be working on the boats."

That's how Alberta, who doesn't even much like fish, wound up serving as not just wife, but first mate for Walter throughout their lifetime together. "I didn't know anything about boats or fishing," she says. Though her tone is wry, there's also an unmistakable love in her voice for this man who's never far from her thoughts. Even after his death, when others were serving as captain of the *Big Dipper*, she continued to carry bait across the street in the early morning haze and to continue her role as first mate on those *Big Dipper* fishing charters until she finally sold the boat just a few years ago.

If the charter fishing and boat rides weren't enough to keep the young couple busy, Walter also bought a bathhouse and snowball stand on the boardwalk and turned them over to Alberta to run. "He had the bathhouse building rebuilt, put in dressing rooms. People would put their clothes in bags and we'd keep them

on a shelf while they were on the beach." She had a frozen custard machine, too. "I wouldn't get home until eleven or twelve at night."

She doesn't recall there being any trouble on the boardwalk back then. "Captain Joe Miller was the only policeman. He walked everywhere. He'd stop somebody and say, 'You're drunk. Go home.' And they would. He didn't stay up too late," she remembers.

Because she and Walter had always been connected by a love of music and dancing, they didn't miss the big bands that performed at Reno, especially Guy Lombardo. "I walked up. He was on the bandstand. He was very nice, very polite. I got his autograph. Walter wouldn't have had the nerve to do that."

Though they bought a condo in the busier and faster-paced Ocean City, Maryland, and enjoyed visiting there, Colonial Beach was home.

"There are very few things I'd change," Alberta says. "We had a good life here."

They raised one son, who died of cancer as a young adult. There's a plaque on the wall in the children's

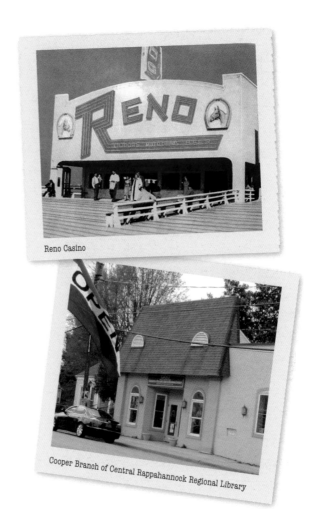

Reno Casino

Cooper Branch of Central Rappahannock Regional Library

section of the local library in memory of Walter Albert "Bert" Parkinson. "He would work on the boat if Walter needed him, but he wasn't crazy about it," she recalls, then picks up a photo cube of snapshots of the young man she lost too soon.

"I kept thinking God was going to heal my son, but He had other plans," she says, her voice still filled with sorrow.

Having a child gave Alberta yet another purpose. "He had plenty of books to read because I saw to it," she declares. And because of that determination, she also saw to it that the town worked toward getting its own library.

"The bookmobile came first, then the library. An elderly woman had a lot of books and she donated them." Because Alberta was also an active volunteer at St. Mary's Episcopal Church, the church found two rooms that could be used to house the growing collection of donated books. It became the library's first location. Then the town was able to give them space in what had once been Greenlaw's Hardware Store on Hawthorn Street.

But Alberta and her friend Bobbi Cooper, whose family had owned Cooper's store on a large piece of property on Washington Avenue, wanted even more. Working with the town and that piece of donated property, they built what is now the Cooper Branch of the Central Rappahannock Regional Library System, which is connected to other libraries in nearby Fredericksburg and throughout the Northern Neck Region.

Alberta has a few other passions in her life. Clark Gable is one and there are photos of him on the walls of her home. She also loves old carousel horses and one sits now in a prime location where she can enjoy it every day, right along with the view of the bay. That view and the mementos of her years with Walter surround her with memories of the two men in her life.

"Not a day goes by that I don't wish they were still here," she says softly, glancing up at a picture of Walter that hangs above the sofa. "Not a day."

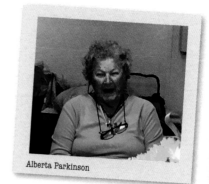

Alberta Parkinson

A COME-HERE WHO STAYED:
Diana Pearson

Practically from the day she was born, Diana Henderson was stirring up trouble. Her mother named her Diane, but when her birth certificate arrived it listed her name as Diana. So from that moment on, the people in her life were split into two camps—those who followed her mother's lead and continued to call her Diane and those who used her legal name, Diana. To this day, folks around Colonial Beach are confused about which is correct.

What no one questions, though, is her energy and her

loyalty to the community she and her family adopted as home when she was only twelve.

"We'd been coming here from Alexandria since my sister and I could walk." Then her parents made the decision to move to town and her father opened a plumbing business. For a time they also had a motel and marina slips to rent on Monroe Bay Avenue where the Nightingale Motel sits now. Her mother cooked meals for the guests—"she cooked everything from scratch."

Diana worked at the school, even before she graduated, to earn extra money. Teacher Sarah Lee found typing jobs for her, and she helped out in the school cafeteria. It was the principal back then who hired her as his secretary, and Sarah Lee, who encouraged her to get her high school diploma at Colonial Beach. Her spirit and determination to finish school after she'd married at only sixteen encouraged other girls who'd quit to come back and do the same.

Perhaps that explains her loyalty to the Colonial Beach Drifters and to the concept of keeping the tiny Colonial Beach school system separate from the county system, so that it continues to have its own identity. It's a hot-button issue in town to this day, driven in part by those who are convinced their taxes would go down if the two systems were consolidated.

The school system is unquestionably small—some thirty-five teachers and fewer than six hundred students from kindergarten through high school, with a graduating class in 2016 of only forty-one.

"I still donate to everything in town," especially any projects that will benefit the school, Diana says of her ongoing attachment to the school system. She was active in organizing a fifty-year reunion for her class that drew many old friends back to town, some of whom seldom return.

Pearson's Seafood

ating crabs

Pearson's Seafood

Diana is not afraid to take on anyone, whether the subject is the school system or town politics. "I've been going to town council meetings since I was thirteen." She remembers things others aren't willing to take the time to hunt down in the minutes from years gone by.

"My problem is, what I think, I say," she says with a shrug. "But at least people know where they stand with me."

Thirteen was about the same age she was when she started volunteering with the legendary Frances

and Jimmy Karn with the Chamber of Commerce. She credits them with teaching her and many others what community service and involvement were all about.

"I started working with the Potomac River Festival in 1958. We had beautiful floats back then," she recalls nostalgically. "We used to have school bands and majorettes. Today groups don't have the money to come, and bands have to turn in their equipment at their schools before Festival week."

The energy that keeps her going today started way back when. "I was never a child to sit idle. I'd hand out trophies, whatever they needed. As I got older, I'd judge two or three categories during the parade." She chaired the baby contests for fifteen years. And for her what mattered was the baby's personality, not whether they were all cleaned up in fancy clothes and tiaras. "The littlest ones were a real joy."

She was thirteen when she met Bobby Pearson while she was walking with friends on the boardwalk. "He asked me if I'd go for a ride with him. I told him he was too old for me."

Bobby Pearson was born in the heart of town on Colonial Avenue to a family that already owned a successful seafood business. Even then he knew what—or most definitely who—he wanted, and it was Diana. She was only sixteen when they got married. "We had forty-seven wonderful years together" before his death.

Bobby's father, George, started Pearson's Seafood in 1935. He opened a small retail seafood store, first on Irving Avenue, then on Hawthorn Street. "He had one truck," Diana recalls. The business moved to its current location on Colonial Avenue in 1961. "Bobby and I took over in 1971."

They sold fish and crabs in season, as well as oysters, but eventually they gave up on oysters and concentrated on hard- and soft-shell crabs.

George Pearson had been a waterman on St. George's Island before he came to Colonial Beach. He and his wife had four children. Bobby was the one who took to the seafood business and had a vision to make it grow on the wholesale side.

"One night Bobby came and told me I needed to tighten my belt because he wanted to work with his

dad. I was about a size two then. I wasn't sure how much tighter my belt could be, but I told him to go ahead."

Father and son expanded their seafood distribution, added freezers and came up with a technological innovation that gave them an edge with the soft-shell crabbing side of the business. To this day that technology is still in use, she says, proudly showing off the room where they cultivate the crabs during the brief time when they shed their shells.

When the oyster supply started dwindling, they did away with their shucking room. "It didn't pay to shuck 'em," she says, echoing a conclusion others in town had come to. "And they weren't good quality."

The rockfish were dwindling, too, but they've since come back. She describes that as a mixed blessing, though, because they eat crabs.

Crab pots

After years of working with watermen from around the region, Diana describes them as "a good, hardworking group of men. A lot of them started in their teens or younger, following in their father's footsteps, but it's beginning to be a dying occupation. It's hard work."

Watermen are out at dawn checking their pots and hauling in crabs. In the afternoon they have to maintain their boats or clean their pots, if needed. "If a pot grows 'hair' on it, it won't catch crabs," she explains.

She says it's not a job that draws a lot of women. Some wives will go out with their husbands, but very few go out on their own. "In 2016, there are none in this area," Diana says. And she's the only woman seafood buyer in the area.

While running the business started by her husband's family keeps her busy, she still makes time to attend those council meetings, to participate in fundraising drives and encourage others to get active.

She admits it's harder now to get young people interested in the way she was drawn to community service. They have too many other activities taking up their time.

"I've always been proud of Colonial Beach. It's the kind of town where, when times get tight, people will buckle down and work."

Over and over she stresses the need for people to get more involved, to show a greater interest in what's going on in town.

That small-town atmosphere is what makes it special. "When I went to school in Alexandria, I was a number, not a name. People didn't see me as a person. Here I had one-on-one contact. We were friends with the teachers."

So, whether it was the attention of those teachers back then, the guidance of the Karns, her marriage into the Pearson family or simply her own personality, Diana has spent most of her lifetime working to make Colonial Beach a better place. She was vice president of the Chamber of Commerce, helped organize the Potomac River Festival and beat on doors to raise funds for just about every cause that's important to the town.

"All we can do now is hope that the youth will get involved and start where we left off."

BUILDING BOATS...
AND A FUTURE:
Mary Virginia Stanford

In 1940 Mary Virginia Tucker was a recent high school graduate working in a bank in Apalachicola, Florida, when a dashing Clarence Stanford and his brother came to town to help their father find some way to settle the debt he owed.

As Mary Virginia recalls, she and Clarence met at a dance hall where young people gathered for an evening of fun for a mere five cents. It was *not*, she says very firmly, love at first sight. He asked her to go to the movies, though,

and she agreed. They saw *Sergeant York*. Her best friend dated his brother, and while those two didn't last as a couple, Clarence was persistent.

After joining the navy, he taught her to drive and left his car with her, then came back to town whenever he was on leave.

It was Clarence's father, William "Captain Billy" Stanford, who brought her north on the train for her first visit to Colonial Beach, Virginia, in 1941, two years before she and Clarence married. Even though Apalachicola was a small waterfront community, comparable in size to Colonial Beach, both with populations well under five thousand and plenty of opportunities for boating and fishing on the waterways, there was one noticeable difference. After coming from the wide expanses of sandy beaches along Florida's Gulf Coast, she looked around at the narrow

Billy and Maria Rebecha Stanford

shoreline in Colonial Beach and asked, "Where's the beach?"

After Clarence left the navy with an honorable discharge as a Motor Machinist's Mate First Class in 1945, there were jobs to be had at the Naval Surface Warfare Center Dahlgren, so the young couple settled in Colonial Beach. The family bought a small

Clarence and Mary Virginia Stanford

marina on Monroe Bay in 1945 from Frank Oliff, but Clarence's travels weren't yet over.

He spent nearly a year in India working for the Office of Strategic Services—a predecessor of the modern CIA—leaving Mary Virginia behind. After his letters describing the conditions he found, he added in one note that the Red Cross center was "the only place over here that even resembles home." That plaintive comment was all it took to give Mary Virginia a mission. She began raising money to send to the Red Cross, just one of the many volunteer projects she would tackle over the years.

By marrying into the Stanford family, Mary Virginia found herself amid a staunch family of men tied to the sea. Her father-in-law, born in 1877 in nearby Lancaster County, went to sea at the age of eleven as a cook's helper on an oyster boat.

In 1898 he served in the navy during the Spanish-American War, meeting his wife in New York during that one-year stint. His wife, Maria Rebecha Lucht, immigrated from Germany at the age of sixteen and was working as a handmaiden for an actress at the time, according to Mary Virginia's great-niece Grace Roble Dirling, whose grandmother was Clarence's sister. They were two of Captain Billy and Maria's twelve children.

Captain Billy Stanford

Captain Billy worked on a variety of vessels before captaining a series of schooners on the Chesapeake Bay, taking cargo up the bay to Baltimore and back. Sometimes that cargo was fish, destined to become fertilizer, a smelly business, Mary Virginia says, her nose wrinkling even now.

There are oft-told stories of Captain Billy operating the three-masted schooners on his own, if need be, when his crew failed to show up on time. In 1940, there are even pictures from the *Washington Post* showing a "crew" of Girl Scouts who worked the boat for ten days.

Captain Billy plied his trade on the waters of the Potomac River, Chesapeake Bay and other waterways for some seventy years. In 1959, he was featured in an article in the *Free Lance-Star* in Fredericksburg, written by Paul Muse. The article showcased his new career as an artist, painting pictures of the boats he loved. He was eighty-one. In the article he is quoted as saying, "I'm going to have to stop giving them away. The cost is starting to add up. It costs fifty-cents for a tube of paint."

Those weren't the only items he gave away. In 1940 he made donations of several historical items—a stern carving and carved trail boards from the pungy schooner *Amanda F. Lewis*—to the Watercraft Collection of the Smithsonian Museum.

Captain Billy died in 1970 at the age of ninety-three.

In the meantime, Clarence and Mary Virginia were making a life for themselves in a small house next to

Chesapeake Bay

Stanford Marine Railway, where he spent summers repairing boats that docked at the marina or were brought in by local boaters. Winters were dedicated to his passion—building boats. Not only did the latter feed his soul, recalls Mary Virginia, but it was a way to keep his crew working year-round. Ironically, that sideline is what truly built Clarence's reputation in the boating world. His boats are prized by their owners.

Stanford built his first boats at the age of fourteen, charging a whopping twenty dollars for a rowboat or only five dollars if the materials were supplied. He'd build the skiffs in his spare time, even on Sundays "if Mother didn't catch me," he told a reporter for the *Richmond Times-Dispatch*.

Through the years, the size and the price of the boats increased dramatically, but his attention to detail never wavered. He prided himself on "putting a little extra" into every boat he built.

He built several fifty-foot boats, though his preference was for the smaller ones, but the quality of his work is indisputable. The *Big Dipper*, a fifty-foot charter fishing boat built for and captained for many years

Stanford Marine Railway

by another Colonial Beach legend, Walter Parkinson, took two winters to build inside the shed at Stanford's marina before being put into the water to allow the wood to swell tight. That boat is in private hands now, but it's still seaworthy today.

In one newspaper report, Clarence stood by while a Coast Guard inspector tested the seaworthiness of the *Midnight Sun*, a sister boat to the *Big Dipper*, and was unable to cause even the tiniest chink in its solid construction.

People came from all over the state for a boat built by Stanford. One man came back three times to buy his "heavenly" series of boats—*Heaven's Sake*, *Second Heaven* and *Heaven's Above*. *Heaven's Sake* was another fifty-foot, twin-screw, mahogany-planked yacht.

In the end, though, Stanford thought the price would be too high if he truly charged what his exacting craftsmanship was worth, so he focused on the smaller boats he could build more cost effectively.

As Clarence operated the marina, Mary Virginia kept the books in the kitchen of their small home. Even after his death in 2006, she continued to keep the marina's books and kept it operating until she finally made the decision to sell in 2014, after the death of their grandson, Stephan, in a pile driver accident at the marina. Stephan had loved working with his grandfather on the boats and took Clarence's death hard. When he was killed just a few years after his grandfather's death, Mary Virginia knew it was time to sell.

By this time, their small home on a neighboring lot had been moved to a larger piece of land across the street, where even now its address and the marina's are often confused by visitors. It was a "Stanford" neighborhood, according to her great-niece, who remembers three Stanford homes in addition to the one owned by Mary Virginia and Clarence. Others, built by Charles Knox, belonged to Helen Stanford Knox, Viola Stanford Groves and Grace's own family.

Through the years Mary Virginia rarely, if ever, questioned her decision to leave Florida as a young bride and settle in Colonial Beach. One of the few times, she recalls, was her first winter at the beach when she hung her clothes outside to dry and they froze. She laughs about it now, but found it pretty unsettling at the time.

She and Clarence raised two daughters, who graduated from the small local high school and went on to college—the oldest to Florida State. She still lives in Florida, not that far from where her mother grew up.

Mary Virginia's married life at the beach revolved around home, the marina, going to the movies from time to time, fishing and crabbing, volunteering and her church. She volunteered for a variety of town events and charitable activities. She still has a very high regard for the efforts of Frances Karn, who always put together Christmas baskets, among many other things, for those who needed them. The town boardwalk is named for her, "as it should be," Mary Virginia says.

She recalls when gambling came to town in the '50s, she didn't show much interest until she heard stories from her friends about their winnings.

"I told Clarence I thought we should go check it out." She hit a jackpot that very first time and came home with about sixteen dollars in nickels. "I bought new paper shades for the windows."

She remembers when roadways were paved with oyster shells, when author Sloan Wilson (*The Man in the Gray Flannel Suit*) and his wife, Betty, lived on their boat at the marina, when bullets flew on Monroe Bay during the Oyster Wars in the late '50s and when friends found a skull that was later determined likely came from the dark days of those oyster conflicts, when men scrambling to make a living fought over rights to the oysters that then thrived in nearby waters.

Today oysters and crabs are scarcer than they once were, gambling has come and gone and the changes to the town don't always sit well, but for Mary Virginia Stanford, Colonial Beach is home. She could go back to Florida where one of her daughters has settled, but doesn't plan to.

She still crosses the street to visit the marina and boatyard that became legendary around town and beyond when her husband was building his beautifully crafted boats. The new owner has turned the showroom into something of a museum, with boating supplies and parts from years gone by, items that Clarence kept around just in case they might one day come in handy.

One of the first friends she made in town, Alberta Parkinson, who worked fishing charters with her husband on the *Big Dipper*, lives just up the street. Another, Ellie Caruthers, touches base often, as do Mary Virginia's daughters.

She looks around her cozy home of more than seventy years and says softly, "I'd like to die here. I hope that's what happens. I love it here. It's my home."

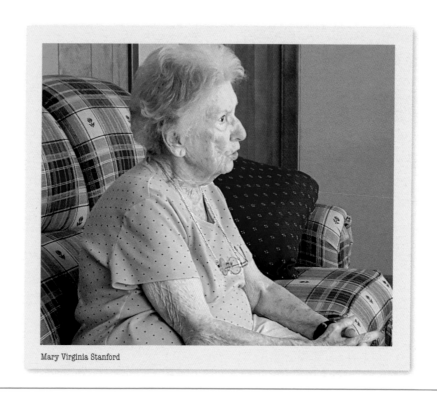

Mary Virginia Stanford

MUSKRAT RAMBLE:
Mike Stine

While just about everyone who grew up in Colonial Beach has spent time on the water fishing or crabbing or simply boating or water-skiing, very few started making a nice living in their early teens from trapping muskrats and otters as Mike Stine did.

Born in 1946 to a waterman from Deal Island, Maryland, who'd married and decided to settle in Colonial Beach, Mike grew up on the water. By then his father had found a more stable career working as a painter at the Naval

Surface Warfare Center at Dahlgren, but Mike had taken a liking to being on the water.

"I trapped every bit of this creek," he says, referring to Monroe Bay, which was glistening behind him on this late summer morning.

His focus was on muskrats, otters, raccoons and, once in a while, foxes. He sold the skins to a man from Lottsburg, Virginia, who'd come up every two weeks. "He'd get me out of school—I was in eighth grade then—and I'd sell him whatever I had. I made good money at it."

Though he did well in school, was in the National Honor Society and even tutored a little, and played junior varsity basketball, "I shied away from anything that cut into my trapping time. I loved the outdoors. I'd be out of the house early in the morning, and Mama didn't see me again till sundown."

There were far fewer homes along the creek back then. Kids didn't spend all their time on computers as they do now. "From December till the end of March I'd spend every waking minute tending to my traps. I had to check them whenever the tide was down, then stay up half the night to skin whatever I'd caught."

Blue heron along the coast of Chesapeake Bay

He and Nealy Little, who still works on the nearby waters, partnered a lot back then. "We caught a lot of fur and had a lot of fun doing it."

Then came the trip back to Deal Island with his father that changed Mike's life. Whenever his dad had vacation time, they'd go back to Deal Island to fish. They usually ate in a small local lunchroom.

One summer after he'd graduated from high school—one of only twenty-five students to graduate from the school that year—he saw the girl of his dreams, the daughter of the owner. "I fell in love with her right away," he recalls.

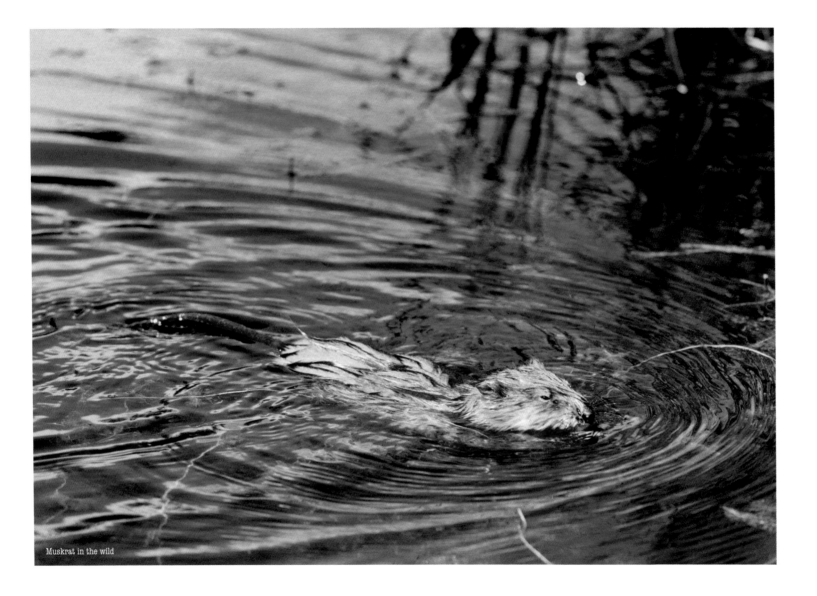

Muskrat in the wild

But she was only sixteen, and her daddy was "kind of a hard man." He wasn't one bit happy about his daughter marrying that young.

"When she turned eighteen, I gave her an engagement ring," he recalls.

They married and settled in Colonial Beach, where they raised two children. His son has cerebral palsy. His daughter has married and has two boys of her own.

When Stine thinks back to his school days at the beach and is asked about any favorite teachers, he smiles at once. "Oh, yes. My fifth-grade teacher, Ernestine Daniels. I loved her as much as I did my own mama. I used to tell my parents, if anything ever happens to you, have her take me in."

It wasn't that she was easy on the kids or the least bit liberal when it came to discipline, but she was kind. "Every day after lunch, she read us a book, fantastic stories. Everybody would listen, slack-jawed. She really cared about her children."

As he recalls his childhood, he can remember times when his family didn't have a lot. "My daddy ruled the roost. He insisted on hot bread for every meal. We had

biscuits in the morning and at lunch and hot rolls for dinner. He instructed my mother what to cook. He never owned a car. He walked or rode a bike." But as tough as times might be from time to time, "there wasn't anybody who ate better than we did. My friends would do just about anything to be invited to stay for supper."

He says that though his wife worked in her mother's lunchroom where they met, he wound up doing a lot of the cooking in his family.

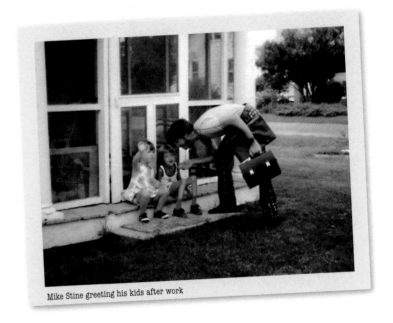

Mike Stine greeting his kids after work

Though church has always been important to him, and he grew up as a Baptist, Stine says in recent years that has changed. He has served as a chaplain at the nursing home in town and took in meals once a month for the residents until he could no longer afford to do it. While he had to stop bringing in meals, he continues to serve as chaplain and conducts Sunday School and Bible study there.

Over time he became disillusioned with denominational religion. "People nowadays want to be entertained. They don't want to talk about sin," he says. "I find there's too much world in the church and not enough church in the world."

That, he says, has changed the role of the churches in Colonial Beach. He attends a small church several miles out of town near Stratford Hall.

Thanks to his own work at Dahlgren, he's had the opportunity to travel all over the United States and even outside of it. Even with Colonial Beach's flaws, he declares, "I've never seen anyplace I'd rather live than this. I love this place. I have a lot of friends. I've had a lot of fun."

When anyone looks back at their life, what more could they ask for?

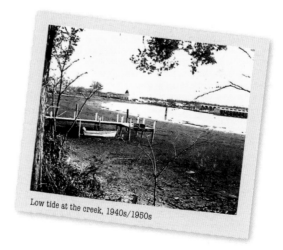

Low tide at the creek, 1940s/1950s

CREATING A SMALL-TOWN ATMOSPHERE: THE POTOMAC RIVER FESTIVAL AND MORE

While big cities have every kind of event imaginable, there's something special about the events in a small town. In Colonial Beach, just as in my fictional small towns, they bring neighbors together to work on the planning. Think of Nell O'Brien and the Chesapeake Shores fall festival or that town's Fourth of July fireworks.

In Colonial Beach, local festivities provide an opportunity for people to get together over barbecue and hot dogs on the town green in much the same way they used to on the boardwalk back in its heyday.

Colonial Beach has lots of these events throughout the summer, but none is more iconic than the Potomac River Festival, held every June for more than sixty-five years now. Sponsored by the Chamber of Commerce, in its early days it was organized by Frances Karn and her brother, Jimmy, with an assist from Delbert Conner. These three, as noted by

Diana Pearson, epitomized the philosophy of giving back to the community.

There is a little something for everybody in this celebration. The Ladies Auxiliary of the fire department brings in a carnival for the weekend. A firemen's parade kicks things off on Friday night, with fire trucks and rescue vehicles from all over the region lined up on side streets, testing their sirens as they wait for the official start of the parade. They can be heard all the way to my house, blocks away.

That parade is followed by the selection of Miss Colonial Beach. Years ago, one of my best friends, Patti O'Neill, was in that pageant and rode on a float in the parade the following day. I still have some very grainy home movies from that year.

On Saturday, the parade once had floats, school bands, majorettes, clowns and Shriners in their little cars, along with local politicians. Senator Mark Warner has been a regular over

the years. The floats are still around, as are the politicians, but school bands aren't available, and there were fewer majorette groups until a concerted effort was made to bring them back.

When I had my bookstore with Mary Warring's Potomac Accents store, we won an award for our "float" one year, primarily, I think, because we were able to use—very, very carefully—one of her husband's prized classic trucks. Trust me when I tell you, the floats done by various businesses and organizations in town are not Tournament of Roses Parade caliber, but they are fun.

On Sunday, as I've previously mentioned, there's a boat parade. And during all of this there are vendors selling arts and crafts and all sorts of food, very little of it healthy, but all delicious.

Events like this unify a community and give it its character. They become the traditions we hold dear.

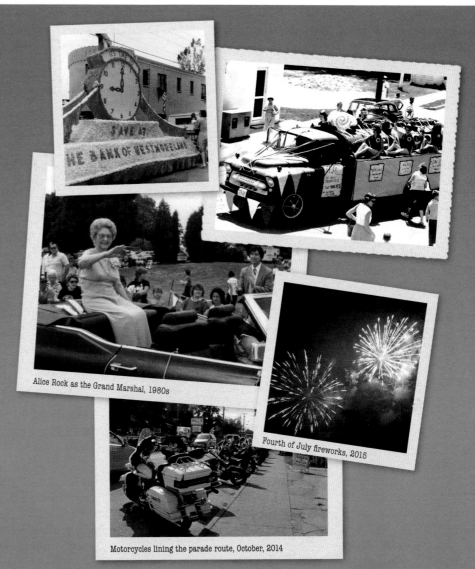

Alice Rock as the Grand Marshal, 1980s

Fourth of July fireworks, 2015

Motorcycles lining the parade route, October, 2014

The Oyster Wars

When walking the quiet streets of Colonial Beach or sitting on the porch watching the watermen's workboats drift by as the sun rises, it's hard to imagine that at one time such serenity was shattered by gunfire on a regular basis. What was even harder for me was the realization that, though I was a regular at Colonial Beach in that era, I remembered absolutely nothing about it.

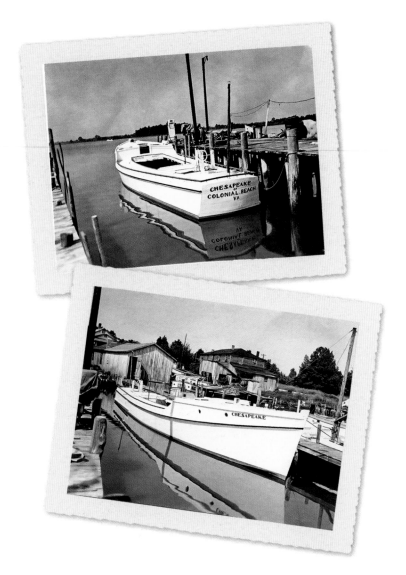

And then, Gladys "Sugie" Green, wife of waterman Pete Green, who lived it and remembers it all vividly, reminded me that oystering went on primarily during the winter months. And, much to my regret back then, I was only a summer kid.

So, though I'd heard the names of many of the key players in this local drama—Landon Curley, William Bozo Atwell (referred to by some as "King of the Oyster Pirates"), Berkeley Muse, Harvey King—the details of what happened during those troubling days were all new to me. It was yet another reminder of why it's so important to hear these stories while those who lived through the events are still around to share their accounts.

Attorney Michael Mayo, whose father, John, represented several local oystermen when they had legal problems with Maryland patrol boats, offered a unique perspective when recounting his own memories of the era.

Michael and Berkeley Muse's son were around the same age and were friends back then. He remembers being with his friend in a local store following Muse's

death. Harvey King, the waterman who'd convinced Berkeley to go oystering on his boat pretty much "on a lark" and who had been shot in the leg in the same barrage of bullets, came into the store, saw them and offered his condolences. His remorse was scant comfort to a young boy who'd lost his dad, Mayo recalls.

Michael also remembers how devastated his own father was by the loss of life. John Mayo held Berkeley in high regard and found his senseless death incredibly tragic.

Years later, Mayo, who is legal counsel to the Potomac River Fisheries Commission, saw a presentation by Berkeley's granddaughter. She had studied oystering for a science project, and made her presentation about the Oyster Wars "dressed like a waterman." For Mayo it was an especially touching moment, a new generation remembering such a tragic, personal moment from her family's past.

Today there are very few oystermen left who were on the waters that fateful night in 1959, though there are any number of people around town who can tell bits and pieces of the story. Pete Green, who was with Berkeley in the hours just before they went out onto the water and whose own boat was being chased by the same patrolmen, comes closest to being an eyewitness, though he made it safely back to shore that night hours before his friend was killed.

It was a night that changed lives, altered laws and perhaps even made a difference in the way people came to regard the tasty delicacies from the river that they'd come to take for granted.

A NIGHT THAT ENDED IN A HAIL OF BULLETS:
Pete and Sugie Green

Theirs was a love story that almost never happened. Pete Green and Gladys Merle Warder, known by everyone as Sugie, were in their teens when they met, both of them admittedly very shy.

"I like to say it began when my sister picked him up to give him a ride uptown," Sugie recalls of the young man who frequently walked past the front porch of her family's summer home on Lafayette Street. "I was not quite sixteen."

She was the daughter of a Washington, DC, police lieutenant in the Ninth Precinct who had once worked as a mounted police officer. Pete was already working several months of the year as an oysterman, following in his father's footsteps. His best buddy and later his partner on the water, George Townsend, began dating Sugie's sister.

"We went together for five years," Sugie recalls. But when Pete received his draft notice, she refused to marry him before he left.

At least some of her hesitation stemmed from growing up with a dad in law enforcement, and Pete very blatantly engaged in illegal oystering on the Potomac.

"He kept promising me he'd stop," she says.

After Pete's tour of duty in the service ended, they started going together again and eventually eloped to LaPlata, just across the river in Maryland, an irony since Maryland was where Pete had already had legal troubles and had been charged with harvesting oysters illegally. The dredging of oysters had been outlawed in the river, but Maryland was far stricter about enforcing the law than neighboring Virginia. Virginia watermen,

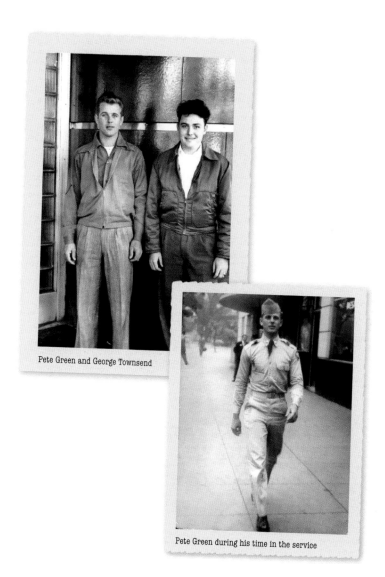

Pete Green and George Townsend

Pete Green during his time in the service

like Pete, often took their boats out at night, hoping to dredge without being detected.

In an article about those early days written only for family and friends, Sugie describes an incident when Pete and two friends from school took out the *Melrose*. They were soon spotted by a Maryland patrol boat, the *Pokamoke*. That boat had a thirty-caliber, water-cooled

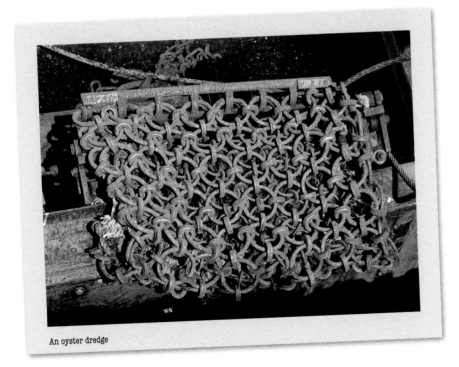

An oyster dredge

machine gun on the bow, operated by Patrol Officer Guy Johnson. He began firing.

Pete's friend, Weensie Atwell, tried to outrun the Maryland boat, but, according to Pete, "Weensie had neglected to fill the gas tank before leaving the docks and the *Melrose* ran out of gas."

Arrested, the boys were taken to Cobb Island and given bologna sandwiches while the officers phoned authorities to decide what to do with them. They were eventually sent home and told to report to Bill Marchant, captain of the Virginia patrol boat. They decided against reporting the incident, according to Sugie's article, but "they each had a lot of explaining to do to their parents" because they'd been out all night.

Even though she knew of such adventures, Sugie hoped they were a thing of the past. After she and Pete eloped, they spent their honeymoon in Daytona, Florida, and discovered that they both liked being warm in winter. It was years, though, before they bought property on the West Coast of the state in Venice and retired there, years that included plenty

of dissension over Pete's continued work on the river.

Oystering wasn't something Pete could give up easily. His parents had divorced when he was around thirteen. He recalls that he and his mom didn't get along all that well.

One day she simply told him, "I'm sending you to live with your father."

His father was living at Curley's Point, on the north side of Colonial Beach, and working an oyster boat for Landon Curley. "I packed a bag and went down there. He didn't even know I was coming."

Spending his time in that environment, going out on the *Margaret* with his father, got into his blood, Pete says. By the time he finished ninth grade, he was hooked. "I wanted to go on the river and work." He played hooky from school when he could, worked with his father for three years and finally convinced Curley that this was what he was meant to do.

"I wasn't all that big, but he said he'd take a chance on me." The days were long, the work exhausting. "When I got home, I'd go right to bed. But I loved the river, loved oystering."

Pete Green's father

Pete Green on a boat (left)

The first night he took a boat out on his own with his own crew—his cousin Carroll Green and Sunshine Dickens—he came back to Curley's with eighty bushels. "I remember the dock was all lit up." When Curley saw their haul for the night, he told Pete he was "a chip off the old block."

For a young man from a broken home, the environment at Curley's created a family for him. "Curley was very fair. I thought the world of him," Pete says.

Pete and Sugie (Gladys) Green

There were always oystermen around, playing cards, gambling and talking. There was dancing, too, and homemade ice cream being churned. The store was open till midnight. Yachts would stop in the summer to gas up. "And we'd go out and fish till daylight," he recalls.

It all sounds idyllic, and for a time, it was. "The police let up on us, because they needed oysters for the military." But when the war ended, they began to patrol the river in earnest.

"We started working at night with very dim lights," Pete remembers.

When they were spotted by the patrols, the goal was to pull in their hauls or abandon them, then head back to Virginia waters as fast as they could.

In Sugie's article, Pete talks about being out one night on the *Little Bill*, one of Landon Curley's boats. They were soon spotted by the operators on one of Maryland's fastest patrol boats, which lit them with spotlights and started shooting. Pete and his crew did everything they could to evade them. "The boats ran into each other two or three times," Sugie reports in her article. When Pete finally made it back to the safety of Virginia waters, the motor on the boat was destroyed and he discovered twenty-one bullet holes in the hull and engine. He apologized to Curley for the engine's destruction, but Curley only said, "At least you brought the boat home." He had the engine replaced, and Pete continued to operate that boat.

Pete was still young enough the next time he was caught that, with local lawyer John Mayo representing Pete and fellow oysterman George Townsend, along with a Maryland lawyer, they were given a three-year suspended sentence, a five-hundred dollar fine and "they took the boat."

Pete did give up oystering for a time after that, but once he returned from his service in Korea, he and George decided to go back into business together and bought a boat they named the *Botcha Me.* They installed a 450-horsepower airplane motor in the boat and became the fastest workboat on the river.

There were other incidents that didn't end as well. In 1956, three boats from Virginia were side by side in the river when the patrol boats approached them. Pete and George Townsend headed home. Harvey King kept going and the patrols boats went after him. Though he tried to evade them, "they shot his boat all up," Pete says.

Scenes like that of gun battles on the river are described over and over by Colonial Beach old-timers who often awoke to the sounds of high-speed engines and gunfire in the middle of the night. Some would even gather on the shore to watch, as if the battles were a performance. But the bullets were real.

Pete and Sugie (center) at prom, 1951

Pete's boat had been one of four boats on the river the night the Oyster Wars turned deadly. Pete and two others returned to shore when they spotted the Maryland patrol boats, but one defiantly returned to the water. Pete was safely home in bed by the time events took an ugly turn.

Harvey King had been back out on the Potomac for two or three hours when the patrol boats once again cornered him. "He had a real fast boat," Pete recalls. In fact, by then many of the boats were equipped with high-powered engines and traveled at speeds that the Maryland patrol boats couldn't match. What the Maryland patrol boats did have, though, were weapons that could fire accurately at long distances and the determination to put an end to the oyster dredging.

On that fateful night, there was a hail of gunfire aimed at Harvey King's boat. Bullets pierced the boat and some even hit buildings on shore, including a sign at Wolcott's Tavern.

"They shot Berkeley Muse and got Harvey in the leg," Pete recalls.

Despite being wounded, Harvey drove his boat back into Monroe Bay—safe Virginia territory—and continued to the dock behind Miller's Crab Shore. Berkeley was taken off the boat, but it was too late to revive him. "Berkeley was dead on the dock," Pete says.

Another with memories of that night, Mike Stine, recalls seeing Berkeley's body on a table inside what was normally the workroom at Miller's, where oysters were shucked in winter or crabs picked in summer. The place was crawling with Virginia State troopers.

Pete, who'd made it safely back to shore hours earlier, was on his way to his day job at the Colonial Beach Yacht Center when George Townsend stopped him and told him that Berkeley was dead.

A lot of things conspired to create that night's tragedy. Harvey King tended to aggravate the patrol boats more than most, taunting them with his speed and maneuvering ability, Pete says. More tragic, Berkeley wasn't even in the habit of going out on the boats.

"He didn't need oystering," Pete says. He was doing well with his other businesses. He had land on the river outside of town that he was developing into a community to be known as Berkeley Beach. His brother Corbin completed that development.

On the night he'd died, Berkeley had been hauling topsoil earlier in the evening when he met up with some of the oystermen. He reportedly had a few shots of whiskey with his friends, including Pete, and Harvey King needed one more man on his boat. Berkeley was up for the adventure.

Pete glances at Sugie as he describes that night. If not the turning point for him, it came close to being the deciding factor in giving up the career he loved. "With two children then, I got to thinking maybe it was time to quit."

Pete went to work at Dahlgren as a painter, a skill he'd also learned working with his father. Eventually,

though, after eleven years in that job, he was having medical issues that doctors said were being aggravated by the paint fumes, so he retired. By then Sugie had also been working at Dahlgren for several years. Pete waited for her to retire before they left Colonial Beach for good to finally build their dream home in Florida. It was a long time coming, but a decision neither of them regrets.

They still come north to celebrate special occasions with their four daughters and one son, who are scattered in Virginia, North Carolina and Maryland. It was on one of those trips recently that they sat down to share their memories.

Pete mentions his children with pride, but there's also pride and nostalgia in his voice when he speaks of the boats he and George owned together—the *Botcha Me* and the *Splish, Splash*—and those he owned himself, the *Wanda Ann* and the *Sugie G.*

"We won workboat races with the *Botcha Me*," he recalls, describing how the competition came down to his boat and Bozo Atwell's, the *Mary E.*, which had been souped up with a 630-horsepower Hall-Scott

navy surplus motor. "I would slow down to make it look like a real race, so we could put on a show," Pete says.

While the dangers of being a waterman during the days of the Oyster Wars created tension for Pete and Sugie, they weathered those days and built a lifetime of memories of their own.

Even so, he admits wryly, "We're real lucky we're still together after sixty-two years."

Pete on his birthday

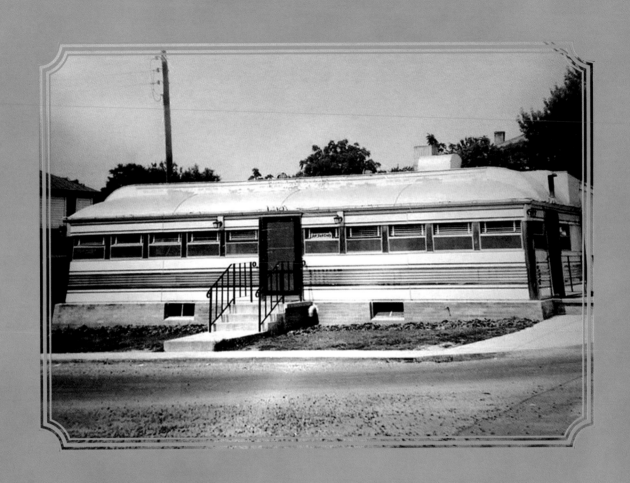

Food for the Soul

In just about every place I've ever lived and in just about every fictional small town

I've ever created, there's always a restaurant where friends gather. In my *Chesapeake*

Shores books and in the TV series on Hallmark Channel, that restaurant is Sally's, a

favorite of the O'Briens. In my *Sweet Magnolias* books, it's Wharton's.

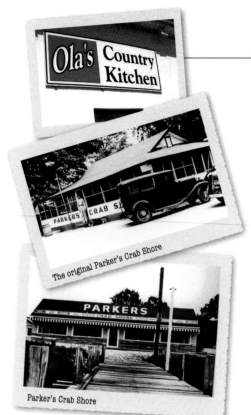

The original Parker's Crab Shore

Parker's Crab Shore

And for me, in real-life Colonial Beach, that restaurant is Lenny's, or as one of my family members insists on calling it, Earlene's, because that's the fictional name I used in *Amazing Gracie*, which she identifies most closely with Colonial Beach.

As in most communities, different crowds gravitate to different restaurants in those early morning hours when coffee and gossip are essential to getting the day off to a good start. It used to be in Colonial Beach, when I needed my plumber, I knew I could find him at Ola's most mornings.

One group of friends in town, all senior citizens, rotated among the various restaurants for dinner every night. I have no idea if they stuck to the same menu selections, but that routine was rarely varied.

In the very early years seafood was definitely king at most of the local restaurants. People debated over which one had the best crab cake, the best steamed crabs or the best hush puppies on the side. Whatever any individual's preference, one thing held true: the eateries were all packed with locals and visitors on the weekends.

For years along Monroe Bay Avenue, parking lots were jammed from Dockside at the Colonial Beach Yacht Center at the Point, to Parker's midway along the bayside road and on to Miller's Crab Shore at the opposite end. Dockside is still serving dinners and offering weekend entertainment, but Parker's is gone, replaced by a house and an empty lot that's still for sale. Miller's has changed hands a couple of times and is now serving Thai-French food under the Lighthouse name.

Many other restaurants in town have come and gone, but one name is constant, Wilkerson's. The family-owned restaurant at the entrance to town has been in business for decades, though not without a bit of family squabbling over the years. Here's the story of the Wilkerson family and their ties to seafood and to the restaurant that bears their name.

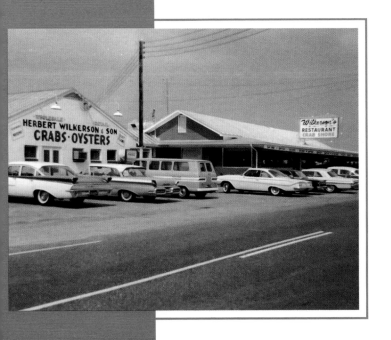

A NAME SYNONYMOUS WITH SEAFOOD:
The Wilkersons

Anyone driving into Colonial Beach on the two-lane road into town knows Wilkerson's. Perched on a narrow spit of land that backs up to the Potomac River, it's been a landmark restaurant for decades. Before the nearby Harry Nice Bridge was built connecting Maryland and Virginia on Route 301, a primary north-south highway, ferryboats brought passengers, cars and even cattle to docks just beside the restaurant.

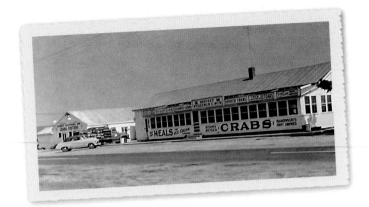

Though that tiny stretch of road in front of the restaurant is referred to as Potomac Beach, it's now considered part of the town of Colonial Beach.

What newcomers may not know and what a few old-timers remember well is that way back there were two Wilkerson restaurants, maybe one hundred yards apart, competing for customers on their way into town.

"The family has been in the seafood business for a long time," Jimmy Wilkerson, owner of the existing restaurant, recalls. "My great-grandfather, Stephen Wilkerson, started the first restaurant in the early 1930s."

It was a natural fit to complement the local seafood industry that most men in the area with the last name of Wilkerson worked in.

Stephen had four sons—William E., Herbert, Butch and Albert—and all had a hand in the restaurant in one way or another, whether it was catching the seafood or helping to run the day-to-day operations.

"When Dad [Walter, Herbert's son] came home after World War II ended, it was already crowded, and there was no room for him in the restaurant," Jimmy says. "So in 1946, Herbert and Walter purchased land down the street and started a second restaurant, where Herbert and his wife, Florence, and Walter and his wife, Catherine, all worked together to get the new business going."

There was no business connection between the two restaurants, despite the family ties and their proximity.

Tensions mounted when Walter applied for a liquor license and his uncle fought it. "There was right much friction at the time," Jimmy says. "They all had right much of a temper."

Friction or not, the two restaurants coexisted for years. Walter's sister, Ellen, later began working in the family business. Walter and Catherine's son, Jimmy, grew up working in and learning the business, as well.

en Wilkerson

Jimmy went away to school to the Fork Union Military Academy during his high school years, then attended college in North Carolina. When he came back in 1970, Jimmy was ready to follow in his father's footsteps by continuing to operate the restaurant and staying in the seafood business.

Jimmy remembers growing up when Colonial Beach was "a robust little town." His father and Denny Conner, one of the brothers who brought casinos and a lot of entertainment to the boardwalk, were close friends. He'd go down to the boardwalk as a child to ride the amusement park rides.

His father had a business strategy that took into account people's gambling habits. Because of the restaurant's location, he liked to catch their attention when they drove into town. "He tried to get them when they were coming in, when he could sell them seafood dinners. On the way out, they were more likely to buy hamburgers," Jimmy says.

After Stephen passed away, the first Wilkerson's restaurant was then run by his son, William E., and later was passed on to his children, Louis, Helen and Stephen. Soon after that transition, Louis came to work for Herbert and Walter after a falling out. When the first location closed in the late '70s, Helen and Stephen joined Louis in working at the current location, as well. Helen, who died in May 2017, was a beloved waitress there for many years.

The original restaurant was later reopened as The Happy Clam, which operated for a number of years, but was destroyed by Hurricane

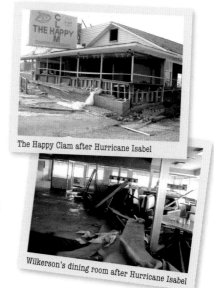

The Happy Clam after Hurricane Isabel

Wilkerson's dining room after Hurricane Isabel

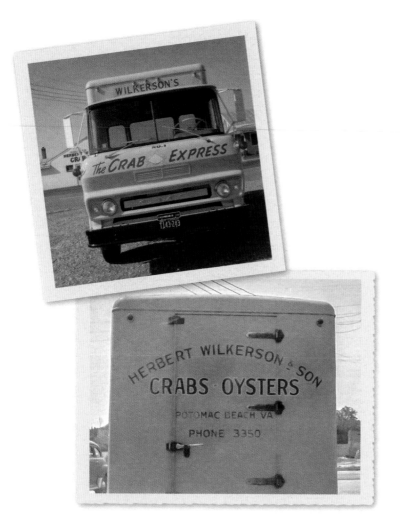

Isabel when it hit Colonial Beach in the fall of 2003. It was not rebuilt, though it did operate for a time at another location in town.

The current Wilkerson's was severely damaged by that September storm as well, but Jimmy had workers on the job almost immediately after, assessing the damage. He reopened the following spring. Wilkerson's is qualified now as the longest continuously running restaurant business in town, celebrating its seventieth anniversary in 2016.

From the late 1940s through the 1970s, Herbert Wilkerson & Sons Inc. had a thriving wholesale seafood business distributing green crabs, oysters in the shell, oysters shucked and packed on the premises, crabmeat, fresh and pasteurized on the premises, and fish caught locally throughout the region. Their trucks ran six days a week and had delivery routes from Baltimore, Maryland, to Washington, DC, to Richmond, Virginia, and even had routes into the Shenandoah Valley.

"At one time we'd sell 150 to 200 bushels of crabs wholesale every week, and we had more than forty daily shuckers when the oyster business was booming.

The staff of Wilkerson's over the years...

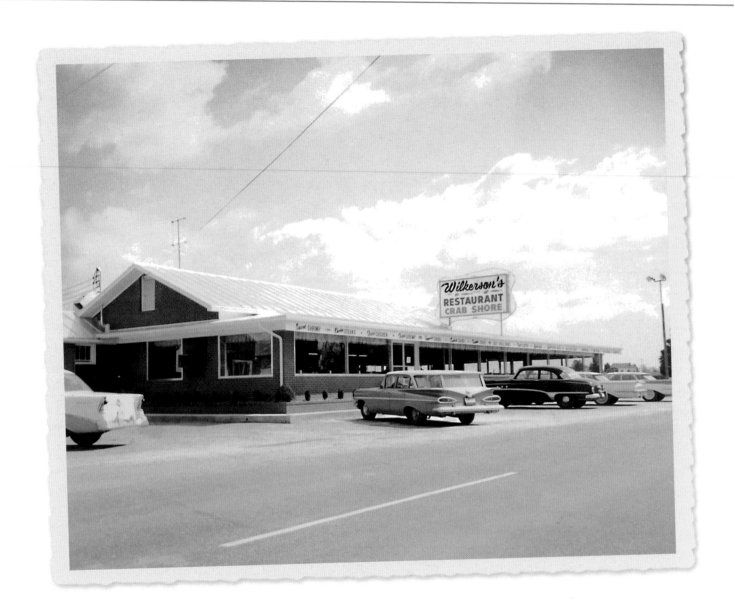

Our oysters went up and down the East Coast from New Jersey to Georgia. In the summers I drove the delivery routes, but I didn't like driving all that much," Jimmy says.

Herbert and Walter were among the first to pasteurize crabmeat, and also grew cultured oysters indoors at one time during the 1970s. The high cost of labor for shucking put an end to the oysters for distribution, and the scarcity of crabs ended the packing of crabmeat for sale sometime later. However, they still serve steamed crabs in season and continue to plant and harvest oysters, which are sold to a local shucker and packer. Some of those oysters come back to be served in the restaurant. Jimmy and his son, Jay, catch the majority of the rockfish they serve in the restaurant in the Potomac River.

Over the years the restaurant was updated and expanded to add a second dining room to meet capacity demands. Their signature seafood combinations and all-you-can-eat seafood buffet are legendary in the area. Each Thanksgiving, they offer a popular Thanksgiving–style buffet for those who choose to

forego cooking and cleaning up. After Thanksgiving, they close for the remainder of the year and open again for business at the end of January.

Jimmy's son, Jay, worked in the restaurant growing up. After studying computers in college, he worked for a few years after graduation at nearby Dahlgren. "I always knew I would be coming back here someday," Jay says. He has been working alongside his father in the family business for more than ten years now, continuing the family tradition.

While much of their focus is on the restaurant and seafood, they also spend a lot of time on their farming operation, which took on a more prominent role after the wholesale distribution business's decline. Soon after Jimmy returned home from college, he spearheaded the beginning of that operation starting with just seventy acres. That has grown significantly over the years and is now approaching four thousand acres, though that acreage has fluctuated recently.

"There's a whole lot of concrete being planted these days," Jimmy says with obvious regret. Good farmland available to work is hard to find.

One of the things both Jimmy and Jay love about their business is that while it's a family operation, those who've worked there for years become part of the family, too. One current employee has been with the restaurant thirty-nine years, and another recently retired after first picking up trash around the restaurant when his mother brought him to work with her when he was just thirteen.

"We also hire a lot of kids for summer jobs," Jay says. "They start out washing dishes and busing tables just like I did, and move up from there. Once they get on here, most of them don't want to leave and stay on for the duration of their high school years, some even longer."

They have all learned to work quickly to keep the tables turning over and the lines of customers moving. Jay's son, Derek, is already learning to bus tables and help out where he can, the same way Jay started out.

What Jimmy finds most gratifying is seeing people who come back to Colonial Beach over the years and have a lot of memories tied to this unique little beach town. He smiles when he adds, "It's nice that this restaurant is one of them."

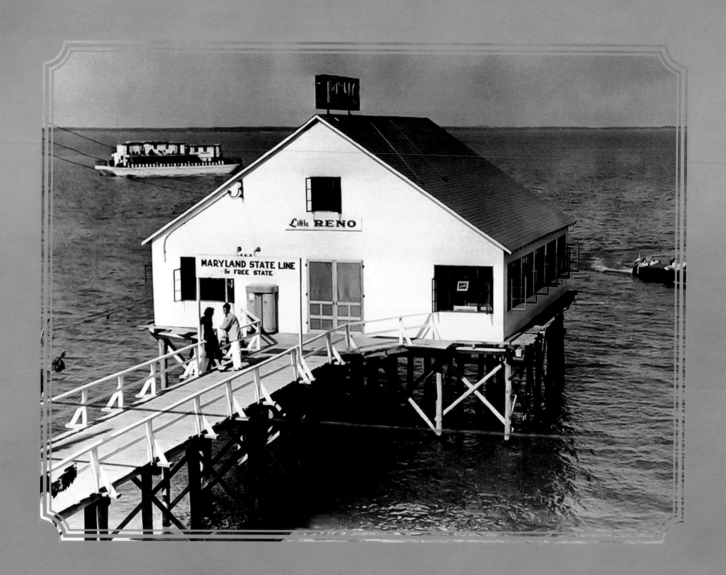

Las Vegas on the Potomac

I am sometimes told by forward-thinking newcomers to Colonial Beach that I am living in the past, that the heyday I remember with such nostalgia will never be again. And while they may well be right, I can't help thinking about how idyllic it all was to a youngster growing up in what seemed to be a full-scale amusement park with nonstop activity all around us during those years when casinos dotted the boardwalk and there was a wide variety of entertainment all within walking distance from home. People-watching, which perhaps prepared me well for writing books, provided endless fascination.

A number of years back I was in the process of renovating the old Baptist parsonage in town to become a bookstore and gift shop. The windows were open to let in the mild spring breeze. Suddenly I could hear an announcement coming over a loudspeaker from the nearby waterfront, calling people to the upcoming boat rides. That sound, that beckoning announcement, took me right back to the boardwalk's heyday and my youth.

It's said that scent stirs memories, but for me it was that crackly sound and its message hinting that an adventurous outing on the water was just a few minutes away. How many times over the years had I heard that same announcement as my friends and I played cards on a blanket by the lifeguard stand on the beach just yards away from the pier where those boats docked?

There was so much fun back then. Sure, we were kids, and fun was our goal in life, but there were few places like Colonial Beach in that era. The pink plane that brought gamblers to town on champagne flights seemed incredibly glamorous. A ride on the little

Outside the Ambassador Hotel

train that circled around under a moonlit sky was always a treat. Miniature golf was great for an evening's entertainment. And the merry-go-round was so indelibly etched on my memory that it became the centerpiece of one of my *Trinity Harbor* books—*Ask Anyone*—in which I got to develop a fictional boardwalk my way.

With my parents, grandparents, cousins or friends, I played endless games of bingo on that real-life boardwalk. Though underage, I slipped into the casinos with my parents and put my share of nickels into the slot machines when no one was looking.

I recall, as if it were yesterday, the night my mom's slot machine started dispensing nickels at an astonishing rate, filling her purse and pockets at a clip that had us both laughing and rushing to try to collect the bounty before someone noticed that the machine was on some sort of wild and mechanically flawed tear.

I also recall the hot summer night in 1963 that Reno, no longer a casino, but still a bone of contention with the Baptist minister in particular, burned. In the morning there were reports that the minister stood on the boardwalk as the flames rose in the sky and declared it was "the hand of God" that finally took it away. Maybe, but it was a very real human who was charged with arson.

Clowning around by the pier

So while there were plenty of detractors in town who disapproved of the casinos and gambling, my family liked to gamble. We always did it with a healthy respect for its dangers. My mother had a twenty dollar limit, whether in a casino or at one of the racetracks we frequented from time to time. My limit remains twenty dollars when I go to one of the Miami casinos, though it's climbed a bit when I go to the races. I think I know more about the thoroughbreds than I used to. I don't.

Whenever my dad's older sister, younger brother and his wife and my cousin came to visit at the beach, we played poker for pennies. I still have an old cigar humidor that remains filled with my dad's winnings.

So, while I do know that the casinos that created the lively atmosphere of my youth in Colonial Beach had their dark side, my experiences were entirely different, as were those of Sandra Conner Scroggs, whose family brought casinos and much of that boardwalk entertainment to town. Here's how she remembers those days, when Colonial Beach gained a national reputation as Las Vegas on the Potomac, thanks to its appearance in an article in the *Saturday Evening Post*. I doubt we're the only ones who remember it this way.

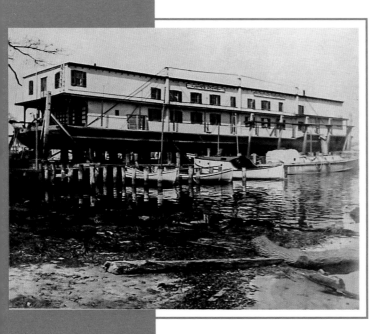

GAMBLING ON A DREAM:
Sandra Conner Scroggs

Colonial Beach residents had a love-hate relationship with the town's gambling era in the 1950s. The minister at the town's largest church preached against it. Businesses thrived because of it. Some complained that gambling destroyed families. Others made their livelihoods in the casinos along the boardwalk. And at the center of it all were the Conner brothers.

It was Delbert Conner who saw the possibilities when gambling was legalized in Maryland in 1949. He knew if he

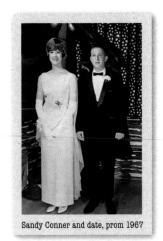

Sandy Conner and date, prom 1967

built casinos beyond the high-water mark in the Potomac River, they would sit in Maryland, making the slot machines legal under Maryland law. Some saw that as visionary. Others viewed it as trouble.

And even with the distance of time and fading memories of gambling's brief heyday in Colonial Beach, there are still those who argue its merits then or debate the possibility of the return of that era in the future as casinos are once again being legalized in Maryland in certain off-track betting locations. Riverboat, built where the Reno and Monte Carlo casinos once stood before being burned, has one of those off-track betting licenses.

No one in town today, perhaps, is closer to the story of that time than Sandra Conner Scroggs, whose father, Paul, along with his brothers, Delbert and Dennis Conner, were at the heart of the town's transformation into what the *Saturday Evening Post* described in one issue as "Las Vegas on the Potomac."

The year-round population in town grew during that era to 2,400 or so. On weekends in summer, it swelled to quadruple that number—or even more by one estimate that put the number of gamblers, families and visitors on any given weekend at twenty thousand—cramming the town's eleven small hotels, five motels, cottages, rooming houses and apartments with tourists who filled the restaurants, patronized businesses and jammed the boardwalk and the beaches to capacity.

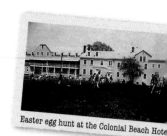

Easter egg hunt at the Colonial Beach Hotel

"Uncle Delbert didn't have children, but he loved little kids. He wanted things for them to do," Sandra recalls. "He dressed up as Santa at Christmas and gave presents to the kids. He held an Easter egg hunt with lots of prize eggs to be found. The Conner kids were not allowed to participate. They did get to color hundreds of eggs for the event, but Uncle Delbert always colored the golden egg and hid that one himself."

He created an amusement park with rides along the boardwalk and built the town pool. Along with Frances

and James Karn, he worked with the Chamber of Commerce and organized the Potomac River Festival. They did baskets of food with turkeys for Thanksgiving and Christmas for any families in need.

"I thought my dad and my uncles were heroes," Sandra says. And yet she adds, "There were people in town who wouldn't let their kids play with me because of the gambling." That resistance faded sometimes in summer, when she had free tickets for the rides and the pool to share with her friends.

For all the negative talk about the type of people drawn to town in that era, she remembers it very differently. "I grew up in the casinos [her family owned three of the six at the time]. I never felt in jeopardy. I went on the boardwalk and never felt threatened. Everyone looked out for you. They felt like family. The summer kids were wonderful. Getting to know them

was like traveling the East Coast without leaving town."

She hates that some people dubbed it the Redneck Riviera or a Poor Man's Las Vegas, because that's not what she remembers at all.

She recalls that customers flew in from Washington on a 1933 Boeing 247 called the Champagne Cruiser. The highly recognizable pink plane landed on a small airstrip just outside of town with its well-heeled passengers. Singer Kate Smith and radio and TV broadcaster Arthur Godfrey were frequent visitors during that era. The people who flocked to town to hear Guy Lombardo, Jimmy Dean and others perform at Little Reno weren't poor. "They dressed up like they were going to a ball," she says.

One of her favorite memories is of the time Patsy Cline performed. Sandra was only six or seven and Patsy had a new baby. There was an apartment upstairs at Little Reno and Sandra was assigned to sit with the sleeping baby and run downstairs to get the singer if her baby woke.

A few years later, her mother and father, Retta and Paul Conner, opened a tiny, walk-up pizza place

virtually on their front lawn on Washington Avenue, just across from the Colonial Beach Hotel. "They did it so they'd know where I was in the summer," Sandra says. "It stayed open later than most places in town so people could eat something before driving home."

For Sandra, the casinos and all of the other Colonial Beach hotels and businesses operated by the Conner brothers and others in their large extended family might have been unusual, but they were still family-run businesses. They took care of their employees.

One man whose family—his mom, grandma and in later years he himself—worked for them was struggling financially. Years later he described to Sandra the night "this big white man [her father, Paul] showed up at their door with money for the rent. He saved my family."

Sandra says she was so proud when she heard the story. "Dad had been dead for a long time. What a legacy of kindness he left his family!"

The Colonial Beach connection for the Conners all started with their great-aunt who encouraged the young Delbert Conner and his eight siblings in a poor

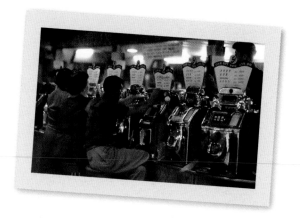

West Virginia family to come to Colonial Beach to work for her at the DeAtley and Ambassador hotels. The Ambassador Hotel became Delbert's first purchase in town. He paid fifteen thousand dollars for it, according to a report in the *Washington Post*, but was left with so little cash on hand that he couldn't pay for the gas hookups for the ovens.

He sold that hotel to his brother, Howard, in 1949 and turned his attention to getting the casinos into town, a business that the *Washington Post* reported made him "a millionaire several times over."

It was 1954 by the time Paul and Retta Conner (she was pregnant with another daughter, Paula, at the time) and their daughter, Sandra, arrived in Colonial

Beach, qualifying Sandra to many as a "come-here." She likes to argue with those who label her that by telling them, "I got here as soon as I could."

She was only five when Hurricane Hazel destroyed several of the casinos, dumping slot machines and liquor into the river and causing a frenzy among people hoping to seize some of the bounty from the water.

By 1958, less than a decade after the first casino opened in Colonial Beach, the movement to force them out had reached a fever pitch and become a political hot potato. Virginia Governor Thomas Stanley was won over by the opponents of the slot machines. He, in turn, won over politicians in Maryland, who banned any casino whose access wasn't from Maryland. The Colonial Beach casinos, of course, were legally in Maryland waters, but were accessed from the Virginia shore. Even today, those walking onto the Riverboat, which is the newest incarnation of what was once Reno, find a clearly marked dividing line between the two states just beyond the front door. It's possible to buy lottery tickets for the respective states on either side of that line.

After the slot machines were banned, they were loaded onto boats and taken upstream to a new location owned by the Conner brothers—Aqualand—at the Maryland base of the Nice bridge across the Potomac.

The entire Jackpot casino was transferred to a barge and floated to its new location, as well.

Still operating with a belief that children should be welcome as well, Delbert created a Storybook Village and a zoo at the new location.

Though the casinos closed, family members—Sandra's great-aunt Mary Curry and her husband, Leo—ran Reno, the Black Cat and the Colonial Beach Hotel for years, maintaining a Conner presence in town.

In general, though, the prosperity of the gambling era dwindled away. Hotels and motels closed. Business along the boardwalk died. Eventually the increasingly run-down structures were torn down. What had once been the thriving Little Reno casino became first Reno, and more recently Riverboat, which ironically depends at least in part on an off-track betting license from Maryland for its success.

When Maryland recently revived casinos in some off-track betting locations, there was talk that Riverboat might be among the chosen spots. When it was rebuilt after being damaged by Hurricane Isabel,

a second floor was added for just that purpose, but thus far it has only been used for private events. Once again, the issue was hotly debated around town, reviving talk of the "element" it might bring to the beach.

For Sandra, whose memories of the time are far more positive, it was motivation to change the record and remind people of all that was good in that long-gone era.

She says that local historian Joyce Coates showed her a photo of a slot machine being operated in a Colonial Beach store well before the first casino came to town. And there were newspaper reports about college kids who came to Colonial Beach to party and caused their own sort of havoc before the first gamblers ever arrived. Ellie Caruthers, who worked for a physician in town at the time in addition to running Doc's Motor Court, recalls being called to those rented cottages in that era to deal with kids who'd had too much to drink, her recollections backing up Sandra's reminders about the past.

Sandra founded a Facebook group, Memories of Colonial Beach, which has an active online presence

with both locals and with those who grew up in town but have since moved away. The group also gathers monthly at Hunan Diner, a Chinese restaurant attached to an actual old dining car, to share personal memories, town history and photographs.

Though she married a marine and traveled extensively, after her divorce Sandra gravitated back to the town where she grew up and the house where she was raised. She still lives and works in Northern Virginia, but spends weekends at the beach and plans to retire there. "You know everybody in town and everybody's friendly," she says.

That doesn't mean there are things she wouldn't change. She'd like to see the school system take better advantage of the nearby experts in various fields at the Naval Surface Warfare Center at Dahlgren.

"I read somewhere that Lord Nelson had his first ship when he was fourteen," she says to explain why more attention needs to be paid to giving broad-ranging experiences to kids at the high school level.

She'd like to see the weekenders who own property take a more active role in the town. More importantly, she'd like their voices to be heard by town officials. Too often, though, they're ignored because they can't vote in town elections. They do, however, pay town taxes, Sandra argues, and should have some say in town decisions that affect them.

When the town's reputation is tarnished, when there's negativity about the past, she's offended by it. "I want to try to heal this kind of stuff," she says, then adds with passion, "I want people to be proud that we have such a unique history in this town."

Riverboat on the Potomac OTB, 2013

A Community's Spirit

Though the very first school in Colonial Beach dating back to 1907 was a one-room building with seven grades and a single teacher, the still-tiny school district holds special memories for just about everyone who grew up in town. Even those who attended high school classes, when they were held outside of town at Oak Grove and the team was called the Vikings, hold tight to a sense of pride now that the high school itself is back inside the town limits and the students are known as Drifters, a name chosen by the students themselves.

The one-room Jefferson School outside Colonial Beach

The Second School built in Colonial Beach

Colonial Beach Elementary School, built in 1912

When enrollment outgrew the sturdier brick building erected in 1912, determined town residents and school officials held fund-raisers of every conceivable kind, including auctioning off a donated house, to raise the money needed to build a new high school.

It wasn't just nostalgia or even the belief that the youth in town needed to have a school system with its own identity, it was the sense of pride people in town take in the school's athletic achievements. For years basketball was the primary source of that pride, but other sports have increasingly added to the community spirit that centers around the school.

As a summer kid, I was seldom around during basketball season, but two of my friends back then played on the high school team. I managed to get to town once to see both Marge Owens and Mike O'Neill play in what is lovingly referred to as "the cracker box" gymnasium.

Alumni go to games. They offer scholarships to encourage college attendance. Some mentor individual students. When the school building that many attended burned down and was later demolished a few

years back, a lot of people wept as flames consumed the building on a cold, wintry morning.

Perhaps no two individuals have done more to foster this sense of community involvement or to attract support for the school's athletic programs than former Athletic Director and Coach Wayne Kennedy and Coach Steve Swope. Both now retired, they talk fondly of the young men they mentored well beyond their athletic feats in basketball, football, baseball and track. They boast proudly of individual achievements and records, of a hard-earned state championship. But mostly they talk about the sense of family that high school sports has created among players...and throughout an entire community.

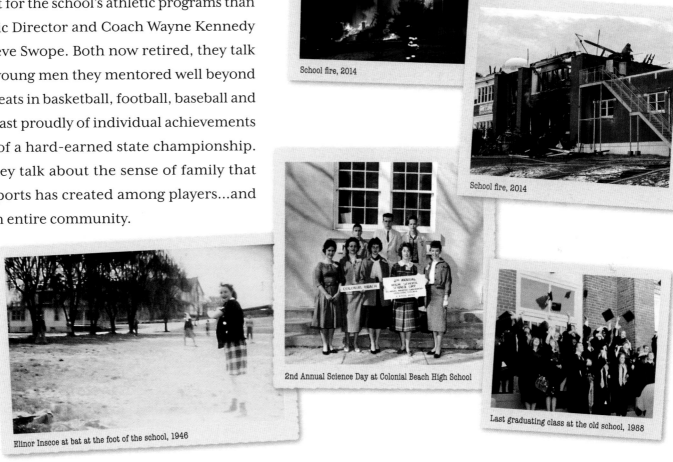

School fire, 2014

School fire, 2014

2nd Annual Science Day at Colonial Beach High School

Elinor Inscoe at bat at the foot of the school, 1946

Last graduating class at the old school, 1988

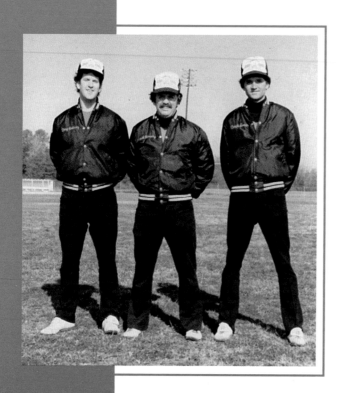

DRIFTER PRIDE:
Wayne Kennedy and Steve Swope

In a town with under five thousand residents and graduating classes so small they're barely the size of an English class in many school systems, sports teams are the pride of Colonial Beach, and few are more responsible for the local legends than longtime Coach Steve Swope and Athletic Director and Coach Wayne Kennedy.

Both retired now, they still have vivid memories of the players and the seasons that brought the town together. None is more memorable than the boys' basketball team

that went to the state finals and brought home the trophy in 2009.

An endless parade of cars, perhaps 350 or more, made its way back to town from Richmond that night. Once home the parade circled the Point, horns blowing, people cheering.

"I looked back and there were car lights as far back as I could see," Steve recalls.

"And by the time the first cars made it around the Point, there was a traffic jam with cars still in line to start going around the Point," Steve says. "It was like the movie *Hoosiers*. We were met by the police, the fire department and the rescue squad."

eve Swope with the "cracker box" table

The magic of that night is memorialized on a sign coming into town. And for Steve, it's also memorialized in two mementos in his home. When the old school gym was torn down after a fire destroyed the original building in 2014, one section of the wooden floor from what was lovingly called the "cracker box" was placed in a shadow box created from an old school cafeteria window. Another, much larger section, was lacquered and turned into a picnic table that is obviously one of his prized possessions.

Coach Kennedy

For these two men, though, that night was the culmination of years of hopes and dreams.

For Wayne Kennedy, who came here with his pregnant wife, Charlotte, when he was just out of college and thought for sure he'd never in a million years take the job, it turned out to be the highlight of a forty-year career. He is quick to point out, though, that "our girls' basketball, baseball and softball teams have won numerous conference and district championships." In fact, the girls' basketball teams, led by Coach Keith Dickerson, have been to the state tournament three years running. Football coaches Scott Foster and

Jeremy Jack have taken their teams to the playoffs seven consecutive years."

But if there have been a lot of successes through the years, Wayne recalls an early one with particular fondness. In his second year as a basketball coach in 1968, the boys' basketball team beat their rival, Washington & Lee from Montross, for the first time in seven years. "The players were so excited, they threw me in the showers with my clothes on. Police Chief John Anderson then led us on a spur-of-the-moment parade around the Point in celebration." It was just a hint of the parade to come so many years later when they triumphed in the state championship.

But as Wayne talks of those successes, he also recalls how it all began. When he and Charlotte visited Colonial Beach after getting a job offer, he was so unimpressed with what he'd seen of the town, he left Charlotte waiting in the car while he was interviewing, anxious to get back to North Carolina. To her shock, he said yes. They stayed for five years, left for two, and then came back to stay for good.

While the basketball team had been strong for years, they were just getting started in football in 1967. "Initially we barely had fifteen kids," he recalls. "They had to play offense, defense and special teams. Some schools had bands bigger than our teams. We called it Iron Man Football."

The teams might not have been big in numbers or the size of their players, but they had a lot of pride. They were successful playing bigger schools in the region and eventually were able to draw other players to the school and add to their roster.

Steve points with particular pride to Torrey Smith, whose family lived in public housing, and whose mom worked two jobs to provide for Smith and his five siblings. "He was our greatest success story." Smith went on to play in the NFL as a standout for the Baltimore Ravens and then moved on to the San Francisco 49ers. He's now signed with the Philadelphia Eagles to be close to home again. He's a local hero, who served as grand marshal of the Potomac River Festival parade a few years back. "He's got a good heart. He stayed close to home so he could help raise his siblings."

Steve can list a long line of players who went on to play for big teams, including Chris Johnson, who played for Louisiana State University, then signed with the Celtics, Timberwolves and Trail Blazers in the NBA.

There were state players of the year, records broken. One player, in fact, T. T. Carey of the 2009 state championship basketball team, set a record in the state for total points scored in a season—880—that was third behind those of Allen Iverson and Moses Malone, other Virginians who went on to become NBA superstars.

Others set baseball records, too, crushing it at bat and pitching with outstanding arms or chasing down anything hit to centerfield. Two Steffeys—Ralph and his grandson Brent—had incredible DNA when it came to baseball. Players would run out to the field by the water tower in the spring when Ralph was still in elementary school in the '60s to watch him hit batting practice. Years later, Steve declares that Brent Steffey "was the best baseball player to ever play at Colonial Beach High School."

Steve Swope with his family

Steve Swope's grandparents

Steve Swope

There were outstanding athletes in track, too. Duck Watts—a four-sport star who was all-state in three of those sports—broke record after record. He was such a fierce competitor that, even though few spectators typically come to track meets, Wayne recalls one school in the region emptied just to watch him compete. "He was a great teammate in other sports, too. He was unselfish. He wanted everybody to be a part of it," Wayne remembers.

"We were the smallest school, had the smallest teams, and we were the underdogs every day we woke up, but we embraced that role. It was fun to beat the bigger schools," Steve says.

Wayne and Charlotte formed such bonds with their players that they often traveled to college games just to see them play.

That sort of mentorship was something Steve understood all too well.

He moved to Colonial Beach as a toddler with his grandmother, living in the area known as the Point. He recalls waking up every day and playing sandlot baseball with his friends. "Then we'd go to Denson's for a

bottle of pop for ten cents, play more baseball till dark, then go and play basketball at a friend's house until his grandma would yell for us to go home."

He remembers it as a simple way of living. "Sure," he admits, "teenagers do some crazy things, but we were really good kids. Sometimes we stepped outside the box. I survived those years."

It was Wayne Kennedy who taught him physical education. "Oh, the fun we had," Steve recalls with a touch of nostalgia. "He inspired me. He was a huge mentor to me. I was a fatherless kid, and he was an important male figure."

Steve went to college at Virginia Tech, then came home to Colonial Beach. "Wayne found me on the boardwalk one day and said you'd best get over to the school and sign a contract to teach elementary school PE."

His wife, Ann, was from Aiken, South Carolina, and, just like Charlotte Kennedy, she wasn't at all sure about making a life in such a small town.

"She changed her tune," Steve says simply. She's had an amazing career in the environmental field

Superintendent Dr. Warner breaks ground for new school

and was later chief of staff at Dahlgren's Naval Surface Warfare Center. "Now she's a die-hard fan of Colonial Beach."

Their three sons all graduated from high school at the beach and went on to college, two to Virginia Tech and one to Radford. One works at Dahlgren and commutes from Richmond. The other two work and live in Charlotte, North Carolina.

One of the things Steve loves is how important school games are to the whole community. Even those without kids on the teams or in the school come out to support the Drifters. If Wayne asked someone to work the snack bar or man the gate at games, they rarely said no.

Coaching didn't end with the close of the school year. They offered summer basketball and baseball camps, summer leagues and Saturday morning leagues. "We'd take the kids to Virginia Tech or James Madison University," Steve says, "to expose them to the opportunities that could be theirs through sports."

They embraced special needs students, too, giving them roles as managers on the team. One young man, Jarod Flores, was designated as a special representative

who was assigned to pick up trophies. In the state championship, Steve was told only the head coach could accept the trophy. "I picked him up, took him to center court and gave him the trophy to raise. There was a picture in the paper of him holding it. He was beaming. It made his life."

Moments like that just added to the important role and mystique that high school sports played in town.

"We had stability with our program," Steve says. "Wayne was athletic director for thirty-eight years, boys' basketball coach for twenty-three years, football coach for seventeen years and boys' track coach for ten years."

Wayne shares credit with Steve, as well. "It was important to have Steve at the elementary level. He could light that fire, see the future Drifter in them."

They name principals and superintendents who believed in their programs, who worked to help find jobs for the kids who needed them, who raised money or even stepped on the pitcher's mound to throw at batting practice.

Longtime school superintendent, Dr. Donald Warner, was so caring and supportive, Wayne recalls.

"He was such a motivator. He deserves a lot more credit than he's ever been given. I'd wake up and think, I just can't wait to go to work for that man."

"I'll second that," Steve says.

It was Dr. Warner, in fact, who spearheaded a fundraising drive to build a new high school. There were bake sales, softball tournaments, car washes, pledges, basketball tournaments, restaurant nights and donations to support the proposed school. "Students collected one million pennies [$10,000] to make Dr. Warner's vision a reality," Wayne recalls. The accomplishment was recognized regionally and nationally for the creativity of their efforts.

Team members and supporters take such pride in their past as a Drifter, they come back to town. They want to be a part of that tradition.

"I tell the kids I stay in touch with that there's a Drifter fraternity," Steve says. "It's the greatest association of friends you'll ever have."

Afterword

So, there you have it, a little glimpse into my world and an introduction to just a few of the neighbors who make Colonial Beach, Virginia, into one of the most unique communities I could ever imagine living in. Some people are larger than life. Others are soft-spoken, but have made their presence felt in different ways.

There are those who enrich the lives of everyone around them with their community spirit of volunteering or giving, who quietly assist those in need or join together in times of trouble with an outpouring of support. This small community, some eighty miles from Washington, but filled with military veterans, rallied in an amazing way after 9-11, providing money and other assistance to those affected by that national tragedy. Members of St. Mary's Episcopal Church took the train to New York to provide assistance in the heart of the disaster area.

Whether the suffering is large-scale or small, there's usually a neighbor willing to rush in and help.

After so many extraordinarily unique periods in the town's history, the evolution continues to determine exactly what identity Colonial Beach will have for the future. Way back when the town's fate was in the hands of lifelong locals like Boozie Denson and Gordon Hopkins, there was always a sense not only of who we could become, but who we had been. Today's town leaders, often "come-heres," with no long-term roots in Colonial Beach, sometimes lose sight of the past

and its importance or of the critical need to respect and preserve it, not only in our buildings, but in our values.

When I had my business, I operated with one major self-imposed rule (aside from good customer service), and that was to keep my nose out of local politics. I knew there was no quicker way to lose business than to take sides. But when town leaders in 2002 and 2003 were determined to sell prime waterfront property, including our town green, to a developer to build condos, I tossed that rule out the window.

Not only did I speak out and generate a petition against it—and lost business in the process—but I worked with others to create yet another event to keep that town green and its stage as a vibrant centerpiece for town activities. Market Days, combined with the Bluemont concert series, was officially sponsored by a local Realtor, run by the Ladies Auxiliary of the Volunteer Fire Department, with all proceeds from the booth rentals going to support the fire department. It was a win-win-win for the Realtor, the fire department and the community.

Hurricane Isabel, which caused sufficient damage to scare off the developer, may have had more to do with saving the green than anything we did, but that event, which lasted a number of years, combined with the long-running Potomac River Festival, the annual Rod Run to the Beach, the newly created Bike Fest and other activities, have preserved the green—for now, anyway—from those who would replace it with privately owned waterfront condos and forever change the landscape along our prime, public waterfront.

There are so many more stories I could share from my past in Colonial Beach. There was the night my old gang went to see a Frankenstein movie at the Mayfair. The girls found it hysterically funny, which deeply offended the guys, so deeply, in fact, that one of them built a life-size replica of Frankenstein ("Frankie's" hair was made from my friend's grandmother's old fur piece) and planted him at my front door one very dark night. After that impressive introduction, Frankie accompanied us on many a prank during those teen years. His head lived in the back of a closet until just a few years back and even became part of my bookstore's

Goosebumps float in the Potomac River Festival parade one year. After that I returned him to his creator to share with his grandkids.

And there was the very steamy summer night when we decided it would be a fine idea to buy crushed ice from the ice plant in town and have a snowball fight in the backyard to cool off. It was a very bad idea, by the way. It's a wonder we didn't end up with concussions. Those "snowballs" hurt like crazy, but we did cool down a bit.

I will forever treasure the memories of those days when we arrived at the beach on a Friday night, and other friends arrived just minutes later on bicycles, dogs tagging along. I can still hear the music of Johnny Cash or the Everly Brothers blasting in the dining room as we played cards, made pizza or, on one regrettable occasion, taffy. There were highly competitive badminton games in the yard. I recall Fourth of July picnics on the beach just down the hill—hot dogs, hamburgers and my mom's potato salad in its orange Fiesta dinnerware bowl—with our carefully chosen fireworks being shot out over the water.

But mostly I remember the sense of family and community and friendship. I hope I've captured just some of that in these pages and in all the books I write. That's where those moments will live on.

Clarence Stanford's sister Catherine

Photo Credits

Front cover: courtesy of Jessie Hall's collection, reproduced with permission by Jessie Hall.

Back cover: Full image: courtesy of Jessie Hall's collection, reproduced with permission by Jessie Hall; A-B: courtesy of Jessie Hall's collection, reproduced with permission by Jessie Hall; C: used by permission by the Wilkerson family.

Front flap: used with permission by Pete and Sugie Green.

p. v: image © iStock.

p. xii: image © iStock.

pp. xiv-xxv: all images courtesy of Jessie Hall's collection, reproduced with permission by Jessie Hall.

p. xvi: image used with permission by Sherryl Woods.

p. xxvi: image used with permission by Sherryl Woods.

p. 2: all images courtesy of Jessie Hall's collection, reproduced with permission by Jessie Hall.

p. 3: image © iStock.

pp. 4-7: all images courtesy of Jessie Hall's collection, reproduced with permission by Jessie Hall.

p. 8: image used with permission by Sherryl Woods.

p. 9: all images courtesy of Jessie Hall's collection, reproduced with permission by Jessie Hall and/or Ellie Caruthers.

p. 11: image courtesy of Jessie Hall's collection, reproduced with permission by Jessie Hall.

pp. 13-17: all images used with permission by Jackie Shinn.

p. 19: all images courtesy of Jessie Hall's collection, reproduced with permission by Jessie Hall.

p. 20: image used with permission by Mildred Grigsby.

p. 21: A: image used with permission by Mildred Grigsby; B: image courtesy of Jessie Hall's collection, reproduced with permission by Jessie Hall.

p. 22: A: image used with permission by Mildred Grigsby; B: image courtesy of Jessie Hall's collection, reproduced with permission by Jessie Hall.

p. 23: image used with permission by Mildred Grigsby.

p. 24: image used with permission by Mildred Grigsby.

p. 25: image © iStock.

pp. 26-31: all images courtesy of Jessie Hall's collection, reproduced with permission by Jessie Hall.

pp. 32-39: all images used with permission by Carlton Hudson, Pat Fitzgerald and from the personal archives of the Rescue Squad and the Fire Department.

p. 40: image used with permission by Burkett Lyburn.

pp. 41-42: all images courtesy of Jessie Hall's collection, reproduced with permission by Jessie Hall.

p. 43: all images used with permission by Burkett Lyburn.

p. 45: image used with permission by Michael Mayo.

pp. 46-47: all images courtesy of Jessie Hall's collection, reproduced with permission by Jessie Hall.

p. 48: image used with permission by Michael Mayo.

pp. 49-51: all images used with permission by the Sydnor family.

p. 52: image used with permission by the Curley family.

p. 53: image used with permission by the Sydnor family.

p. 54: image used with permission by Marguerite Staples.

pp. 56-58: all images courtesy of Jessie Hall's collection, reproduced with permission by Jessie Hall.

pp. 59-65: all images used with permission by Rocky Denson.

pp. 66-73: all images used with permission by Marguerite Staples.

p. 74: image © iStock.

pp. 76-79: all images courtesy of Jessie Hall's collection, reproduced with permission by Jessie Hall.

pp. 80-86: all images used with permission by Ellie Caruthers.

p. 87: image reproduced with permission by Ellie Caruthers.

p. 88: image courtesy of Jessie Hall's collection, reproduced with permission by Jessie Hall.

pp. 90-91: images used with permission by Ellie Caruthers.

p. 92: image © dreamstime.

p. 93: image courtesy of Jessie Hall's collection, reproduced with permission by Jessie Hall.

pp. 94-96: all images used with permission by the Curley family.

p. 97: image © 123RF.

pp. 98-99: all images used with permission by the Curley family.

p. 100: image reproduced with permission by Kitty Norris.

p. 102: all images used with permission by the Curley family.

p. 103: image used with permission by Kitty Norris.

pp. 104-108: all images used with permission by the Mears family.

p. 109: image © iStock.

p. 110: all images used with permission by the Mears family.

p. 111: image reproduced with permission by Ellie Caruthers.

p. 112: image used with permission by Alberta Parkinson.

p. 113: image © dreamstime.

p. 115: A: image used with permission by Pete and Sugie Green. B: image courtesy of Jessie Hall's collection, reproduced with permission by Jessie Hall.

p. 116: image used with permission by Alberta Parkinson.

pp. 117-120: all images used with permission by Diana Pearson.

p. 121: image © dreamstime.

p. 123: image reproduced with permission by Frank A. Alger, Jr.

pp. 124-125: all images used with permission by the Stanford family.

p. 126: image © 123RF.

pp. 127-128: all images used with permission by the Stanford family.

p. 130: image reproduced with permission by Frank A. Alger, Jr.

p. 131: image reproduced with permission by Frank A. Alger, Jr.

p. 132: image © iStock.

p. 133: image © 123RF.

pp. 134-135: all images courtesy of Jessie Hall's collection, reproduced with permission by Jessie Hall.

p. 137: all images courtesy of Jessie Hall's collection, reproduced with permission by Jessie Hall and the Memories of Colonial Beach Facebook group.

p. 138: image © fotolia.

pp. 140-141: all images courtesy of Jessie Hall's collection, reproduced with permission by Jessie Hall.

pp. 142-143: all images used with permission by Pete and Sugie Green.

p. 144: image © iStock.

pp. 145-149: all images used with permission by Pete and Sugie Green.

pp. 150-152: all images courtesy of Jessie Hall's collection, reproduced with permission by Jessie Hall.

pp. 153-154: all images used with permission by the Wilkerson family.

p. 155: A: image used with permission by the Wilkerson family. B-C: images used with permission by Jessie Hall.

pp. 156-159: all images used with permission by the Wilkerson family.

p. 161: image © dreamstime.

pp. 162-73: all images courtesy of Jessie Hall's collection, reproduced with permission by Jessie Hall and Sandra Conner Scroggs.

pp. 174-177: all images courtesy of Jessie Hall's collection, reproduced with permission by Jessie Hall.

p. 178: image used with permission from Steve Swope.

p. 179: A: image used with permission from Kitty Norris. B: image used with permission by Wayne Kennedy.

p. 181: all images used with permission from Steve Swope.

pp. 182-183: all images courtesy of Wayne Kennedy's collection, reproduced with permission by Wayne Kennedy.

p. 184: A and B: images used with permission from Steve Swope. C: image used with permission by Wayne Kennedy.

p. 185: image used with permission by Kitty Norris.

p. 186: image used with permission by Sherryl Woods.

pp. 188-190: all images courtesy of Jessie Hall's collection, reproduced with permission by Jessie Hall.

p. 191: image used with permission by the Stanford family.